Rubens

IN ANTWERP

LUDION

Photo credits
Artothek: pp. 9 bottom, 14 bottom, 24; Bridgeman Art Library: pp. 6 right, 9 top, 12 top, 18 top, 20 bottom,
21 top, 26 left, 27 top left; Collectiebeleid Antwerpen: pp. 71, 80–83; Collection Dexia Bank: pp. 28 top right and
bottom right; KIK-IRPA Brussels: pp. 72–79, 84–85; Kunsthistorisches Museum Vienna: pp. 26 right, 28 left;
Hugo Maertens: pp. 6 left, 8 bottom, 21 bottom left, 52–69; Musée des Beaux-Arts Nancy: p. 13 bottom right;
Museo del Prado Madrid: p. 23 top right; National Gallery London: p. 12 bottom; The Picture Desk: p. 20 top;
Plantin-Moretus Museum Antwerp: pp. 11 top right and bottom right, 13 bottom right, 50–51; Royal
Museum of Fine Arts Antwerp: pp. 5, 7 bottom, 10 bottom, 15 top, 18 bottom, 22 bottom, 27 top right, 32–49;
Rubens House Antwerp: cover, pp. 4, 7 top left and right, 8 top, 10 top, 14 top, 15 bottom, 16, 17, 19, 21 bottom
right, 22 top left, 23 bottom left and top right, 25 right, 29–31, 86–95; SCALA: p. 11 left; Tijdsbeeld/Pièce montée:
p. 25 bottom left.

Translation
Peter Mason

Editing
First Edition Ltd, Cambridge

Design
Griet Van Haute

Colour separations, typesetting and printing
Die Keure, Bruges

www.ludion.be
ISBN 90-5544-515-0
D/2004/6328/21

Foreword

Peter Paul Rubens was not only one of the most prominent representatives of the art of his day, the Baroque, but also one of the most productive and brilliant artists who ever lived. He was exceptionally versatile: besides many religious and mythological subjects he also painted portraits and landscapes, and designed book illustrations and tapestries as well as executing architectural and sculptural designs. He was an outstanding colourist, for whom the virtuoso use of a highly differentiated palette was a major vehicle of expression. Rubens was also an inspired and imaginative illustrator of dramatic scenes. In this connection he was called the 'Homer of painting' by the French Romantic painter Eugène Delacroix. He achieved a harmonious equilibrium between an unfettered imagination and his striving for a balanced and orderly composition.

His works are to be found in large numbers in all the major museums of the world, from Stockholm in the North to Florence and Madrid in the South, from St Petersburg to New York, and further to Los Angeles, without forgetting Paris, Berlin, Munich and Vienna. But there is one city that could be regarded as his real 'biotope': Antwerp, where the house and studio in which almost all of his masterpieces were conceived and painted are open to visitors; where the homes of his friends, Balthasar Moretus and Nicolaas Rockox, are situated; and where his masterpieces can be viewed in the historical churches, that is, on the sites and locations for which they were originally painted.

This book is about the presence of Rubens in Antwerp. It focuses on the biography of the master and the development of his art. In doing so, it refers time and again to works that are characteristic of that development and that can be seen in the city beside the Schelde. In this way, the visitor is presented with a clear and comprehensible picture of Rubens' personality, his life and his art.

The second part of this book provides brief comments on the illustrations of works that are to be seen in the churches and museums of Antwerp, grouped by location. This book is in fact a vademecum, a dependable guide for those who want to get to know the great master in his own surroundings.

Frans Baudouin,
Honorary curator of the Rubens House

Early years

Peter Paul Rubens grew up in Siegen, Cologne and Antwerp against the background of the Eighty Years War. The struggle between Catholics and Protestants and his education in the Latin school were to be decisive for the rest of his career.

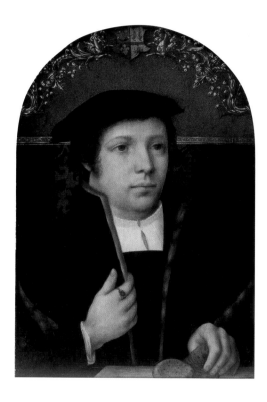 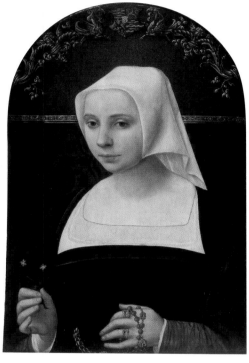

Jacob Claesz. Van Utrecht, *Bartholomeus Rubens* and *Barbara Arents, also known as Spierinck*, 1529–1530. Panel, each 56 x 36.5 cm. Antwerp, Rubens House. The pendant portraits are of Rubens's grandparents on his father's side.

very attached to his brother Philip, who was three years older.

Jan Rubens died in 1587, and Maria Pypelinckx and her children moved to Antwerp soon afterwards. By now the political situation had changed there, as the commander and diplomat Alexander Farnese had reconquered Antwerp for the Spanish king and for Catholicism in 1585. At the same time the division between the North and the South Netherlands had become an irreversible fact. The North now formed the Republic of the United Provinces headed by a Council of State and a *Stadholder*, while the South was under Spanish rule and was administered by a governor. The Protestants had the option of converting to Catholicism or leaving. So Rubens's mother was able to settle in Antwerp on condition that she adhered to the Catholic faith.

The separation between North and South failed to bring about peace: both parties grimly fought on. During his early years – and in

Peter Paul Rubens was born in Siegen, a small town in Westphalia, on 28 June 1577, the name day of the Apostles Peter and Paul. His parents, the Antwerp lawyer Jan Rubens and Maria Pypelinckx, had fled from Antwerp in 1568. Jan Rubens, who was sheriff of Antwerp, was suspected of Protestant sympathies, which was very dangerous at that time, when a bloody war of religion was raging in the Netherlands between the Protestants and the Spanish ruler. The family moved to Cologne, where Jan Rubens became legal adviser to Anne of Saxony, the wife of Prince William of Orange (the Silent), one of the leaders of the revolt against Spain. Later the family settled in Siegen, although they were able to return to Cologne soon after the birth of Peter Paul. It was in Cologne that Rubens spent his childhood until he was almost 12 years old. There were several children in the family. Peter Paul was

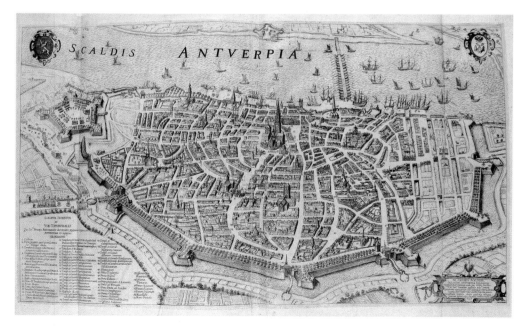

Plan of Antwerp in the commemorative publication *Pompa Introitus Ferdinandi*, published by Theodoor van Thulden and printed by Jan van Meurs in Antwerp, 1642. Antwerp, Rubens House.

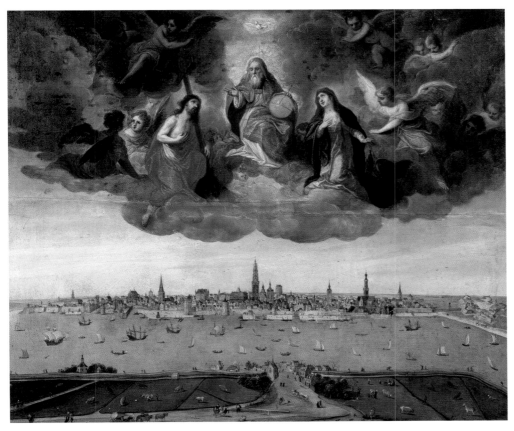

fact, the whole of his life – Rubens endured a background of war and political and religious division. To make matters worse, France joined in the conflict with the intention of annexing the South Netherlands when the time was ripe. These were events in what is known by historians as the Eighty Years War (1568–1648), a war in which the whole of Europe eventually became embroiled.

Peter Paul attended the Latin school (or Catholic school, as it was known) near Antwerp cathedral, where he studied Latin grammar and literature as well as Greek. Throughout his life he continued to deepen his knowledge of the culture of classical antiquity. When he was 13 or 14 years old, he left school to become a page in the service of Marguerite de Ligne, widow of the count de Lalaing, who lived in the Oudenaarde (Audenarde) region, but after a few months he returned to Antwerp, where he began training as a painter. ●

Abel Grimmer and Hendrik van Balen, *Antwerp with a Part of the 'Vlaams Hoofd'*, 1600. Panel, 37 × 44 cm. Antwerp, Royal Museum of Fine Arts.

Concise chronology of Rubens's life

28 June 1577 P.P. Rubens is born in Siegen, Westphalia, on the name day of the Apostles Peter and Paul. His parents, the Antwerp lawyer Jan Rubens and Maria Pypelinckx, had fled from the Netherlands because of war.
1578 The family settles in Cologne.
1589 After the death of her husband, Maria Pypelinckx returns to Antwerp with her children.
c. 1591–1598 Peter Paul studies successively with Tobias Verhaecht, Adam van Noort and Otto van Veen.
1598 Admission to the Guild of St Luke as a master painter.
1600–1608 Residence in Italy as court painter to Duke Vincenzo Gonzaga; contact with the Italian Renaissance; in 1603 takes part in a diplomatic mission to the Spanish court.
1608 Returns to Antwerp.
1609 Court painter to Archduke Albrecht and

his wife, Isabella, with permission to stay in Antwerp and to work there for himself; marries Isabella Brant.
1609– Important commissions, including much religious art to redecorate the churches after the war of religion; affirmation of his artistic vision as a Baroque artist.
c. 1615 Prestigious city residence in the Wapper, with a large studio.
1617–1620 Collaboration with Antoon van Dyck, including the decoration of the Jesuit Church in Antwerp.
1621– After the death of Archduke Albrecht, he is political counsellor to the Infanta Isabella until her death in 1633. As a diplomat and artist, he receives honours and knighthoods at home and abroad.
1622–1625 Commission from Marie de' Medici to decorate two galleries in the Palais du Luxembourg in Paris.

1626 Death of Isabella Brant.
1628–1630 Diplomatic missions to Spain and London.
1629–1635 Commission from King Charles I of England to decorate the ceiling of Whitehall in London.
1630 Marries Helena Fourment.
1633 Dean of the Guild of St Luke.
1635 Purchases a country house, Het Steen, near Elewijt, where he will spend several summers.
1636–1638 Commission from Philip IV of Spain to decorate the Torre de la Parada hunting lodge.
30 May 1640 Death of P.P. Rubens in Antwerp.

Artistic training and the Italian period

Rubens left for Italy at the age of 23. In Italy he drew inspiration from the enormous wealth of works of art from Graeco-Roman antiquity, became acquainted with the oeuvre of great Renaissance artists such as Da Vinci, Michelangelo and Titian, and sampled the first expressions of the new artistic tendency: the Baroque.

Rubens trained successively under the landscape painter Tobias Verhaecht and the painter of rather lifeless religious scenes Adam van Noort, but he was not very much influenced by either teacher. More important for his future was his three-year apprenticeship in the studio of Otto van Veen, whose works included robust altarpieces and allegories with mythological figures in a somewhat cold and static classicist style. An example of his work can be seen in the cathedral in Antwerp: *The Last Supper* (1592), and in St Andrew's church: *The Martyrdom of St Andrew* (1599).

The painting *Adam and Eve* [p. 90], which – if the attribution to Rubens is correct – is one of the rare early works of the artist to have survived, displays a strong stylistic affinity with the work of van Veen, but it is more powerful and sculptural.

In 1598–1599, soon after completing his training under van Veen, Rubens was enrolled as a master in the Antwerp Guild of St Luke. In the following year, 1600, he set out for Italy to complete his artistic training there. He soon found a position at the court of Vincenzo I Gonzaga, the duke of Mantua. Rubens could admire paintings by the great 'modern' masters in the duke's beautiful Renaissance palace. However, he did not spend much time there. The duke, who was regularly in arrears in paying his salary, allowed him a measure of freedom so that he could travel and study as he pleased. His stays in Florence, Genoa and above all Rome were important. He keenly studied Graeco-Roman sculpture, the art of the Italian High Renaissance, and architecture. While in Rome he made numerous copies and study drawings of ancient sculptures such as the *Belvedere Torso* and *Laocoon*, of engraved gems, and of paintings by such Renaissance artists as Mantegna, Leonardo da Vinci, Raphael, Michelangelo, Titian, Tintoretto, Correggio and others. At the same time he was receptive to the new Baroque style in art, which was manifested in Rome at that time in the oeuvres of Carracci and Caravaggio. In Genoa he collected architectural plans and drawings of the façades of palaces, which he later had engraved in Antwerp and published in 1622 as a book of plates (*Palazzi di Genova*).

In March 1603 Rubens was dispatched by the duke to Spain to accompany a convoy with gifts for King Philip III and several court dignitaries, including the powerful duke of Lerma. This visit gave him the opportunity to discover masterpieces by Renaissance painters

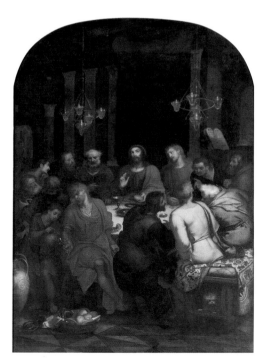

Otto van Veen, *The Last Supper*, 1592. Canvas, 350 × 247 cm. Altarpiece for the fraternity of the Most Holy Sacrament, Antwerp, Cathedral of Our Lady.

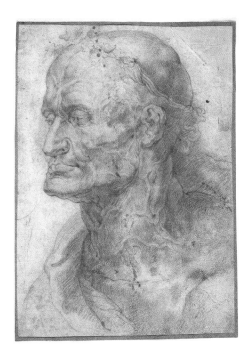

Peter Paul Rubens, *Study of the Head of an Old Man*, 1600–1608. Red chalk on paper, 23.3 x 15.5 cm. Antwerp, Rubens House.

received a genuinely major commission from Vincenzo Gonzaga, who had until then generally given him less important work, copies and so on, to do. He made three gigantic canvases for the Jesuit church in Mantua: *The Gonzaga Family in Adoration of the Most Holy Trinity*, *The Baptism of Christ*, and *The Transfiguration*. During his stays in Genoa he painted, among other things, portraits of the aristocracy. From 1605 on spent most of his time in Rome, where he stayed with his brother Philip, who was employed by a cardinal as his secretary and librarian. Among the works that Rubens produced in Rome was one commissioned by the Oratorians for the sanctuary of the Chiesa Nuova. When the painting was put in place above the altar, however, it was not a success because of the way it caught the light. The young artist promptly produced a second version, in three panels and on slate, a less reflective material.

In October 1608 Rubens left Rome in a hurry after hearing that his mother was dying. By the time he arrived in Antwerp she was already dead. He had spent eight years in Italy, but never returned.

The first works that he produced in Italy still bore the traces of his training with Otto van Veen, but it was not long before all kinds

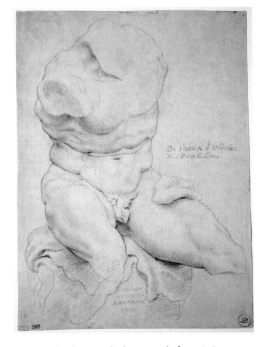

Peter Paul Rubens, *Belvedere Torso*, before 1608. Pencil and black chalk on paper, 37.5 x 26.9 cm. Antwerp, Rubens House.

of new impressions made their presence felt: the art of antiquity, the warm, silvery Venetian palette, the influence of Michelangelo, Raphael, Tintoretto, Titian and others. The *disegno* became freer, the colour took on a vibrancy and a wealth of nuances, and under the influence of ancient sculpture the compositions acquired a heroic monumentality. Rubens later used his drawings and studies of ancient sculptures and Renaissance works of art as a source of inspiration for his mythological and religious figures. He employed this material, together with his drawings of live models, throughout the rest of his career as a repertoire of images from which he could select as he chose, but he always integrated these elements in a lively and original manner. •

like Titian in the Spanish royal collection. In Valladolid he painted the impressive *Equestrian Portrait of the Duke of Lerma*, a painting whose Baroque execution marked a turning point in his artistic development.

After returning from Spain, he at last

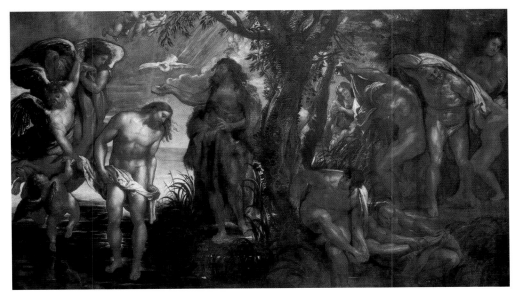

Peter Paul Rubens, *The Baptism of Christ*, 1604–1605. Canvas, 411 x 675 cm. Antwerp, Royal Museum of Fine Arts.

A future in Antwerp

The Twelve Years Truce and the Counter-Reformation encouraged a growth of religious art. Rubens was inundated with commissions for paintings and altarpieces for many of the Antwerp churches. He was given the opportunity to develop the new style that he had acquired in Italy with exuberant colours and lines on monumental canvases.

Studio of P.P. Rubens, *Portrait of Archduke Albrecht* and *Portrait of Archduchess Isabella*, 1616–1617 or later. Canvas, each 119 x 86 cm. Antwerp, Rubens House.

triumph of Catholicism, a movement known as the Counter-Reformation. Churches and monasteries that had been damaged and neglected during the religious wars and had usually been stripped of their artistic treasures were now restored to their full splendour, and new churches were built too. There was thus a large demand for altarpieces and for religious art in general. The climate was particularly favourable for a new artistic élan in the commercial metropolis of Antwerp, where many artists and well-to-do art-lovers lived. Guilds, organisations of craftworkers and fraternities each wanted an altar of their own with a beautiful painting in their parish church or in the cathedral, and wealthy burghers and aristocrats liked to demonstrate their prosperity by making donations to the Church in the form of works of art.

'FOR CHURCH AND KING'

Rubens immediately received commissions for altarpieces and other religious paintings. Only a few months after his return from Italy, the city of Antwerp commissioned him to paint an *Adoration of the Kings* for the Town Hall, where international peace negotiations were to be held. It was probably around this time that he also painted the altarpiece *Disputation on the*

Although he missed his friends in Italy ('whose good conversation makes me often long for Rome'), Rubens decided to stay in Antwerp. By now the political and military situation of the Low Countries was somewhat rosier. Shortly before the death of the ageing Spanish King Philip II in 1598, he had transferred the administration of the Netherlands (in practice only the South Netherlands, because the North had broken away) to his Austrian nephew Archduke Albrecht, who married the Infanta Isabella, Philip's oldest daughter, in 1599. The country was no longer dependent on Spain but became an independent nation, at least for the duration of the government of the childless archducal couple; afterwards the Netherlands was to fall under Spanish rule again. A Spanish army was still stationed in the South Netherlands, and the archduke and archduchess swore eternal loyalty to the Catholic religion, circumstances that somewhat aroused the suspicion of the authorities in the North, although they were not bothered by Spain for the time being. As for the new governors, they wanted to achieve a lasting peace as soon as they could.

When Rubens arrived in Antwerp in 1608, high hopes of an imminent peace treaty were in the air. The Twelve Years Truce was proclaimed in April 1609, and the hostilities came to a halt for a good decade. This policy of peace made the archducal couple extremely popular among the populace.

Now that peace had been restored in the country, the economy picked up dramatically. The reconstruction was marked by the

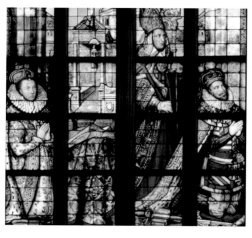

The Archduke Albrecht and Archduchess Isabella in Adoration before the Cross, 1616. Stained glass. Antwerp, Cathedral of Our Lady.
The stained-glass window was a gift from Albrecht and Isabella to the cathedral.

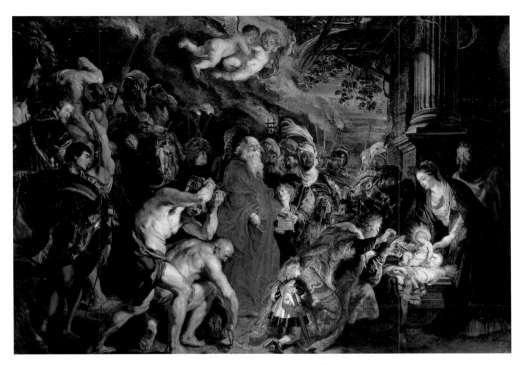

In September 1609, at the age of 32, Rubens was appointed 'Painter of the House of their Highnesses'. He accepted this prestigious position on condition that he would not have to move to the court in Brussels. One of the reasons why he preferred to stay in Antwerp was the 18-year-old Isabella Brant, a daughter of the city registrar Jan Brant, whom Rubens married in October 1609. A year later he purchased a property with a piece of land in the Wapper, in the parish of St James and close to the Meir, the grandest boulevard of the city. He had the house renovated in accordance with his own design in Renaissance style and added a studio to it. In the meantime he moved in with his parents-in-law in the Kloosterstraat. His daughter Clara Serena, the first of the three children that Isabella Brant was to bear him, was baptised on 21 March 1611. •

Peter Paul Rubens, *The Adoration of the Magi*, 1608–1609 and 1628 (additions). Canvas, 346 × 488 cm. Madrid, Museo del Prado.

Nature of the Holy Sacrament [p.75] for the fraternity of the Holy Sacrament in the Dominican church in Antwerp (now St Paul's church). He did another large painting for the same church during the same period, *The Adoration of the Shepherds* [p.76], but it is not known who commissioned it. In 1610 he completed *The Elevation of the Cross* [pp.52–53], an altarpiece for the high altar of the (no longer extant) church of St Walburga which was commissioned by the church wardens. This triptych was a sensational way to introduce to those living north of the Alps the new style that Rubens had come to know in Italy and that was so perfectly in tune with the spirit of the Counter-Reformation. His monumental formats, which were unknown before his time in these parts, and the lively verve of his compositions produced a great impression. He soon became the most important painter in the South Netherlands.

> Peter Paul Rubens, *The Artist and his Wife in a Honeysuckle Bower*, 1609. Canvas pasted onto panel. 178 × 136.5 cm. Munich, Alte Pinakothek.

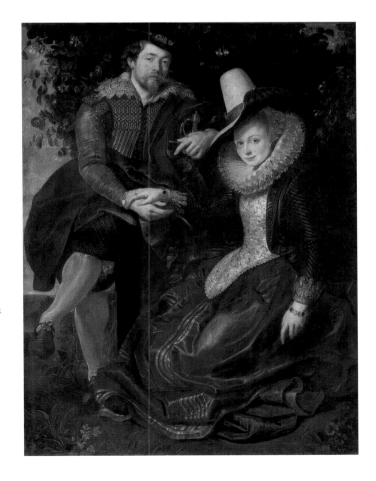

The unfolding of a great talent

Rubens was a man of the world. He moved in the higher social circles and shared with many contemporaries a humanistic temperament that was supported by a wide sense of culture and a refined way of life. His *Descent from the Cross* introduced a more moderate and controlled style.

At first Rubens remained strongly influenced by his Italian models. *The Elevation of the Cross* [pp. 52–53] was a synthesis of what he had learned during his stay in Italy. It is a monumental composition, a muscular sculptural *disegno* à la Michelangelo, as can clearly be seen, for example, in the executioner's assistants in the central panel, and the rich Venetian palette. Rubens also betrayed a strong impetuous nature in that painting. The diagonal composition is full of dynamism and play of colours, the figures are rendered in twisted and bent postures or leaning backward with pathetic gestures, the brilliant highlights on their bodies contrast with the darker tonality of the robes, and the women's curls and horse's mane are shown in violent movement.

This exciting style is a general characteristic of Rubens's works from the years 1609–1612. That is why that first period is sometimes called the *Sturm und Drang* period in his artistic development.

After only a few years his style evolved in the direction of more control and calm, as can be seen in *The Descent from the Cross* [pp. 56–57], which he painted between 1611 and 1614 for the altar of the Guild of Harquebusiers in the cathedral. The composition displays simplicity and clarity, and the postures and gestures are more restrained than in the earlier works. This marked the start of a new stage in his artistic development, the 'classical' period. The colours are brighter and there is less contrast between them; a few colours that have

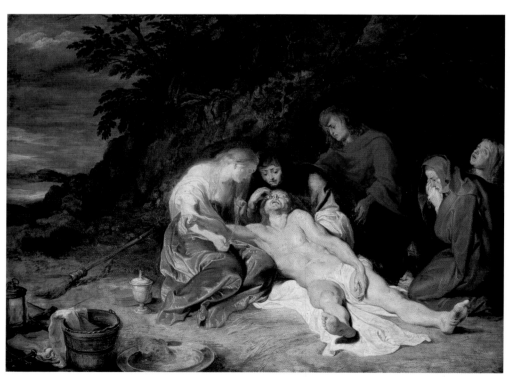

Peter Paul Rubens, *Lamentation*, 1614. Panel, 55 x 73 cm. Antwerp, Royal Museum of Fine Arts.
The landscape background was painted by a different Antwerp artist.

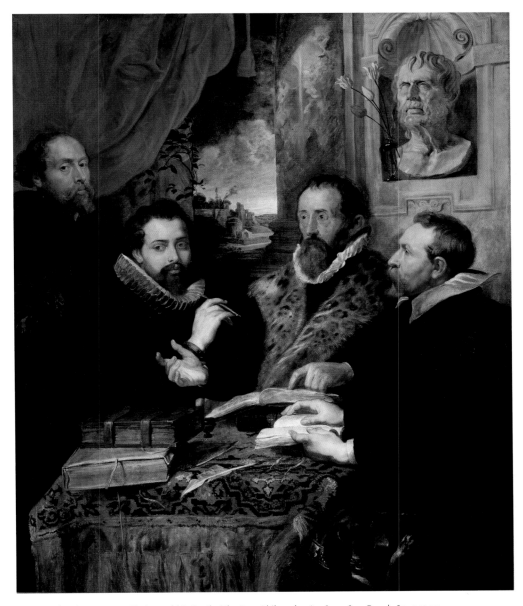

Portrait of Filips Rubens, engraving by Cornelis Galle after P.P. Rubens, in Ph. Rubens, *S. Asterii Amaseae Homeliae*, Antwerp, 1615. Antwerp, Plantin-Moretus Museum.

Peter Paul Rubens, *Justus Lipsius and his Pupils (The Four Philosophers)*, 1611–1612. Panel, 67 x 143 cm. Florence, Galleria Pitti.

Erasmus II Quellinus, *Portrait of Balthasar I Moretus*. Grisaille on panel, for the engraver Cornelis Galle. Antwerp, Plantin-Moretus Museum.

been kept within the contours are evenly distributed over the composition. The *disegno* is as linear and sculptural as before, but the contours are generally less strongly indicated. A bright, cool and more evenly spread light confers relief on the forms that are often set against a neutral background. There is a silvery sheen to the colours. These characteristics recur in Rubens's mythological and religious scenes from the years 1612–1615. Examples are *The Resurrection of Christ* [pp. 62–63], the

allegories *Venus Frigida* [pp. 34–35] and *The Four Continents* [p. 12], the *Triptych of the Incredulity of St Thomas* [pp. 32–33] that Rubens painted for his friend and patron Nicolaas Rockox, and the small panel for private devotion of *Mary in Adoration before the Sleeping Infant* [p. 72].

This was also the period in which Rubens painted the group portrait *Justus Lipsius and his Pupils*, also known as *The Four Philosophers*. Seated behind a table with books, the South

The *Four Philosophers* illustrates the Neo-Stoic ideas that the artist shared with his cultivated circle of friends all over Europe. In Antwerp he moved in a milieu of humanistically inclined patricians, rich merchants, prelates and high-ranking civic authorities – such as the mayor Nicolaas Rockox, the civic officer Jan Gaspar Gevartius, the merchant Cornelis van der Geest, the printer Balthasar I Moretus, and the prior of the Antwerp Dominicans Michael Ophovius – who shared a great predilection for the culture and art of classical antiquity and for the Italian Renaissance, which had its roots in that culture.

Rubens was connected with the élite of Antwerp by virtue of his intellectual training and through various family ties. That élite also provided his earliest clients. Nicolaas Rockox was captain of the Harquebusiers when this guild commissioned *The Descent from the Cross* [pp. 56–57], the painting *Samson and Delilah*

Peter Paul Rubens, *The Four Continents*, c. 1615–1616. Canvas, 208 x 283 cm. Vienna, Kunsthistorisches Museum.

Netherlandish humanist Justus Lipsius is teaching two students, Johannes Woverius (right) and Rubens's brother Philip (left). The painter has done a self-portrait somewhat in the background and in the shadow. He was no pupil of Lipsius, but he admired him and adhered to his philosophy. The ancient bust in a niche was at the time thought to be of Seneca. An identical bust could be found in Rubens's own art collection. The four tulips symbolise the men portrayed, two of whom were dead when the painting was made: two tulips still have to open up, the other two are in full bloom. Peter Paul probably painted *The Four Philosophers* (the fourth philosopher is Seneca, not Rubens) in memory of his brother, who died in 1611.

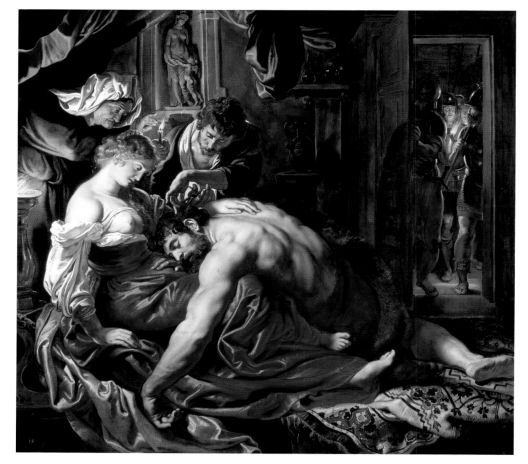

> Peter Paul Rubens, *Samson and Delilah*, c. 1609. Panel, 185 x 205 cm. London, National Gallery.

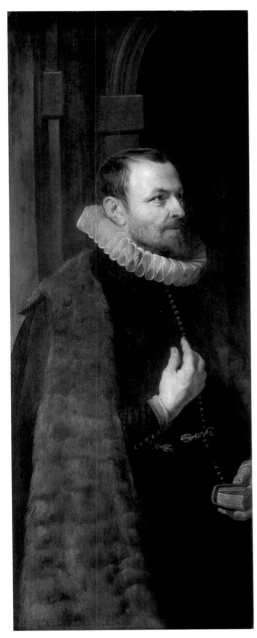

Portrait of Nicolaas Rockox on the left panel of *The Incredulity of St Thomas*, the triptych that Rubens painted for the future funerary chapel of Rockox and his wife in the church of the Friars Minor in Antwerp.

hung above the chimneypiece in his drawing room, and he commissioned Rubens to paint a triptych for his future chapel. The Moretus family also commissioned several works from the artist, including a triptych for the chapel of Jan I Moretus, the father of Balthasar. The Antwerp Dominicans, under Michael Ophovius, acquired a number of paintings by Rubens for their church over the years. Cornelis van der Geest, a prominent parishioner of the St Walburga Church, secured the commission for *The Elevation of the Cross* [pp. 52-53] for Rubens. And these are only a few examples. In the course of time the painter also produced portraits of fellow burghers, relatives and friends such as Gevartius [p. 48], Ophovius [p. 94], and many others.

Besides being an appreciated artist, Rubens must have also been a very appealing personality. The few self-portraits show a man with a cultivated and attractive appearance. Roger de Piles gave the following description in 1677: 'He was of large stature, had a dignified bearing, regular features, rosy cheeks, chestnut hair, eyes that sparkled but with a tempered glow, and a cheerful, gentle and honest appearance.' The same biographer described Rubens's personality thus: 'He had a friendly appearance, an accommodating character, a natural conversation, a clear and penetrating mind, a thoughtful way of speaking and a pleasing voice; that all made him naturally eloquent and convincing.' De Piles acquired his evidence from, among others, a cousin and son of the artist. Incidentally, many documents and letters of his contemporaries have been preserved that refer to Rubens in glowing terms. He also maintained an intensive correspondence with learned friends abroad. Through his eminence, his pleasing manner and his broad culture, Rubens was held in high esteem not only by his Antwerp entourage and his foreign correspondents but also in the highest courtly circles. •

Peter Paul Rubens (?), Portrait of Jan I Moretus, 1612–1616. Antwerp, Plantin-Moretus Museum.

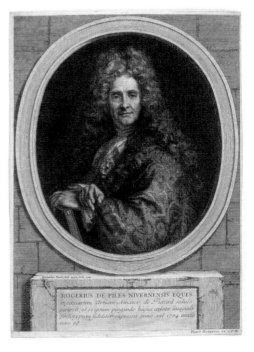

Engraving by Bernard Picart after the Self-portrait of Roger de Piles. Nancy, Musée des Beaux-Arts.

Protagonist of Baroque

All over Europe the princely courts and well-to-do merchants invested in art. The Baroque was now widespread and popular, and artistic studios went through a boom. Rubens was able to renovate and furnish his residence in the Wapper, making of it a small city palace that formed a monumental testimony to his artistic views and personality.

After the conclusion of the Twelve Years Truce, travel increased again in the South Netherlands and foreigners who visited the wonderful churches in Antwerp were confronted at first hand by the overwhelming paintings by Rubens. The artist soon received commissions for similar 'Contra-Reformation' altarpieces in churches in Brussels, Ghent, Lille, Lier... And a few years later, more, and more important, commissions began to arrive from abroad. So the circle of clients was already growing.

Susanna and the Elders, woodcut by Christoffel Jegher after P.P. Rubens, 1630s (?). Antwerp, Rubens House.

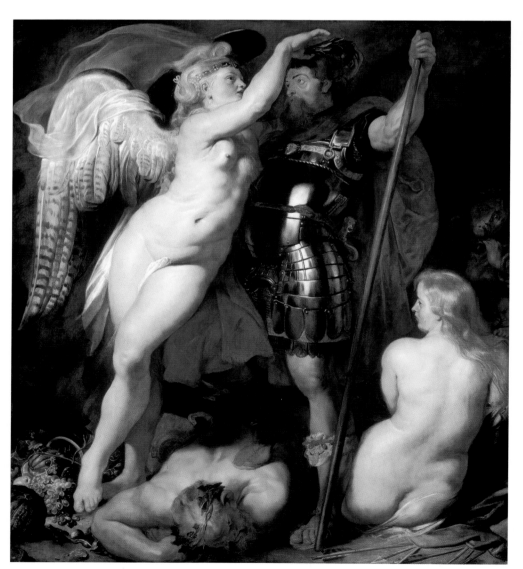

Peter Paul Rubens, *The Coronation of the Virtuous Hero*, 1613–1614. Panel, 221.5 × 201 cm. Munich, Alte Pinakothek.

Of course, Rubens did not confine himself to religious themes, although that genre was strongly represented in his oeuvre. The burgher élite and the nobility were keen to decorate the drawing rooms or best rooms of their residences with paintings. That public was interested not only in religious themes, but also in mythological and allegorical subjects, landscapes, still lifes, genre paintings, hunting scenes, and especially portraits, usually in a small or medium-sized format. Rubens's works for these clients included numerous mythological and allegorical paintings. He often celebrated nudity, above all female nudity, in those works. He was able to render it with an unparalleled radiant sensuality and elegance, tangible and elevated at the same time, with a sensitivity that increased as time went by.

These favourable circumstances and an intense creative energy enabled Rubens to finance the renovation of the buildings in the Wapper. Around 1615 he moved into the spacious residence that he had thoroughly redesigned in Renaissance style. The private

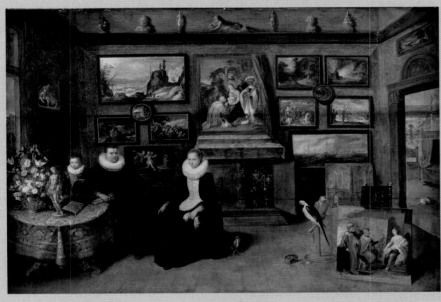

Frans Francken the Younger, *The Cabinet of Paintings of Sebastiaan Leerse*, c. 1630.
Panel, 77 x 114 cm. Antwerp, Royal Museum of Fine Arts.

Jacob Jordaens, *As the Old Sing, So the Young Pipe*,
detail, 1638. Canvas, 128 x 192 cm. Antwerp,
Royal Museum of Fine Arts.

In the first half of the seventeenth century, art – and not just religious art in the spirit of the Counter-Reformation – underwent a boom in several cities in the South Netherlands. As in the previous century, there was a particularly strong concentration of artists and capital in the commercial metropolis of Antwerp. Because of the economic stagnation resulting from the religious war, the merchants and capitalists had invested en masse in works of art because of the lack of other investment opportunities. Some rich townspeople assembled stunning collections that were exhibited in a *Kunstkammer*, comprising not only paintings, drawings and engravings by old and contemporary masters, but also ancient sculptures, Roman coins and medals, curiosities and the like. To satisfy the enormous demand, a tremendous and multifaceted production of paintings and sculptures got under way in numerous workshops. Rubens was the dominant figure, but it should not be forgotten that the South Netherlands had no shortage of first-rate artists. They appropriated the new Baroque idiom and gave this style a character of its own with great talent and virtuosity. Their work found its way to the local art-lovers, to the court of the archdukes and governors, and also to the international market and princely courts, for the same style and the same repertoire were in demand everywhere.

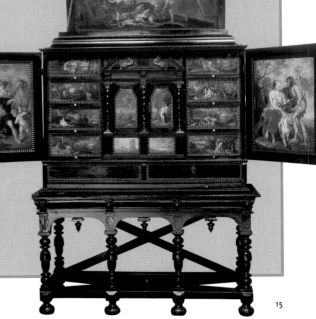

Antwerp luxury cabinet, first half of seventeenth century. Limewood and mahogany, decorated with small paintings, most of which are based on works by Rubens. Antwerp, Rubens House.

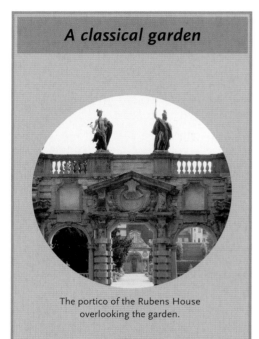

The portico of the Rubens House overlooking the garden.

The triple-arched portico leading to the garden was surmounted by two figures of ancient deities: Athena with her helmet and Hermes with his herald's staff. The cartouches above the two side arches were inscribed with quotations from the Roman poet Juvenal: *Permittes ipsis expendere numinibus, quid / conveniat nobis, rebusq[ue] sit utile nostris / carior est illis homo quam sibi* (Leave it to the gods to give what is fit and useful for us; man is dearer to them than to himself) and *Orandum est ut sit mens sana in corpore sano / fortem posce animum et mortis terrore carentem / nesciat irasci, cupiat nihil* (One must pray for a healthy mind in a healthy body, for a courageous soul, which is not afraid of death, which is free of wrath and desires nothing). Behind the portico was a balustrade overlooking the garden, which was laid out geometrically in classical style. The path through the middle of the garden led to a small temple with other statues designed by Rubens: Hercules, Bacchus, Ceres and Honos. There was also a fountain and a pergola supported by caryatids, sileni and nymphs.

The dining room in the Rubens House.

quarters were in one wing, while the workshop was on the other side. A Baroque portico divided the courtyard from a charming garden. This grand city residence with a façade 36 metres wide and a garden of 1200 square metres was one of the most beautiful sites in Antwerp, but then, Rubens was one of the richest of its citizens. The whole formed a monumental testimony to his artistic views and personality: it was a showpiece of Baroque in the Netherlands and an expression of the artist's Neo-Stoic philosophy of life.

The building, the interior and the garden were altered after Rubens's death and then were left in neglect for a long time. A large-scale campaign took place between 1937 and 1946 to restore the original appearance of the artist's home as far as possible: some parts were reconstructed, but there are still many original elements such as the portico and the garden pavilion. Today the Rubens House is a bustling museum. The interior has been furnished with historical furniture and household items to give visitors an idea of where Rubens lived and of his multifaceted personality. Works by Rubens himself, his mentors, pupils and colleagues hang there, and attention is paid to his art collection for, like many of his rich fellow townsmen, Rubens was a passionate collector of the art of his day as well as of ancient sculptures, coins and gems. And it was in the studio that he accomplished the lion's share of his immense production, thereby adding a new chapter to the history of art. •

Spectacular productivity with the help of the studio

In order to meet the growing demand for paintings, Rubens established a studio in his new home in the Wapper in which several assistants could engage in production, including Antoon van Dyck. The studio ran at full steam like a real centre of industry under the supervision of the master. Rubens's style was now characterised by an unprecedented Baroque vivacity, and he applied the use of colour and interplay of lines to the subject at hand with the greatest ease.

Rubens was finally able to use his studio in the Wapper in 1615 or 1616, and it signified a major improvement in his organisation of work. By now he was so famous and so inundated with commissions that he was increasingly obliged to fall back on assistants. He had previously lacked the necessary space – in his own words, since 1611 he had had to refuse 'more than a hundred requests'. The new studio enabled him to develop a spectacular level of activity with the aid of a large, well-trained group of pupils and assistants. Nevertheless, the quality of the work always remained of the same high standard. This was also the period when

he carried out an obligatory commission for the archduke and archduchess: the execution of their official state portraits, which were subsequently copied several times in the studio, to the irritation of high-ranking court officers and civic boards.

The contribution of the studio varied from one painting to another. Some works, even monumental ones, were painted entirely by the master himself, others were begun by the assistants and drastically modified by Rubens, while in others Rubens painted the essential parts and left the rest to his assistants. The pupils also made replicas of works that were in great demand.

Antoon van Dyck

Peter Paul Rubens, *Portrait of Antoon van Dyck*, c.1615–1616. Panel, 36.5 x 25.8 cm. Antwerp, Rubens House.

From about 1617 to 1620 the young Antoon van Dyck (1599–1641) was working in the Rubens House; he was the main assistant there – Rubens called him 'the best of my pupils' in 1618 – and he played a large part in the elaboration of the cartoons for the cycle of tapestries. The collaboration with Rubens was decisive for his artistic development. He was incredibly good at imitating the master's style, which made him an ideal studio assistant, but he also developed a personal, immediately recognisable style of his own. Van Dyck left his native city of Antwerp at the end of 1620 and travelled to London and Italy, where he discovered the work of Titian; apart from Rubens, this Venetian painter was his major source of inspiration. Van Dyck gradually moved away from the heroic style of Rubens, and built a reputation primarily as a portrait painter. Gracefulness with aristocratic allure, elegant poses and a palette marked by soft gradations of colour are characteristic of his oeuvre. In 1632 he became court painter to the king of England and exercised a lasting influence on English painting.

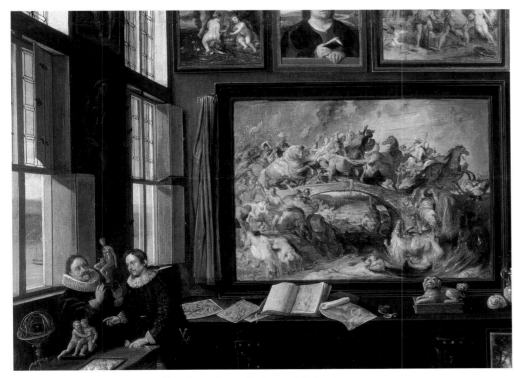

Willem van Haecht, *The Picture Gallery of Cornelis van der Geest*, 1628. Panel, 100 x 130 cm.
Detail showing *The Battle of the Amazons* by P.P. Rubens. Antwerp, Rubens House.

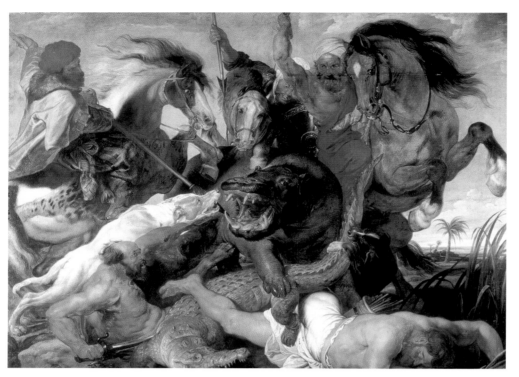

Peter Paul Rubens, *Hippopotamus and Crocodile Hunt*, 1615–1616. Canvas, 248 x 321 cm. Munich, Alte Pinakothek.

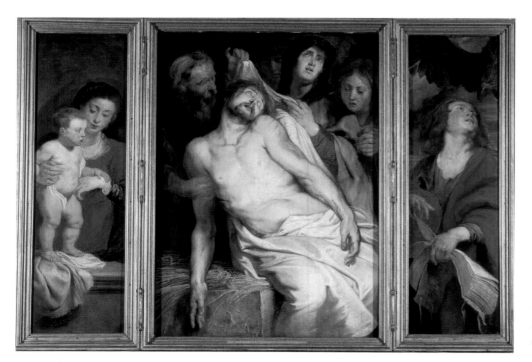

Peter Paul Rubens, *Christ on the Straw*, c. 1618. Panel, 138 x 98 cm (central panel), 136 x 40 cm (side panels). Antwerp, Royal Museum of Fine Arts.

After 1615, Rubens's paintings once again became more dramatic and lively. He developed a theatrical High Baroque style, sometimes of ecstatic religious subjects, for example, but also in a number of highly dramatic hunting scenes, which he executed for aristocratic clients at home and abroad, and in battle scenes such as *The Battle of the Amazons*, a work that was given a place of honour in the art collection of Cornelis van der Geest. Rubens had developed his skills within a few years to such an extent that he now had a whole range of styles and tonalities at his fingertips that he could apply depending on the theme. The movements of the figures became more supple, the palette became more varied, and the contours were less clearly delineated. The strong contrasts that had characterised his work during the first years after returning from Italy now disappeared, as did the colours within clear contours that had featured during his classical phase. They were replaced by harmonic transitions and gradations, with alternating light or dark tones, but always within a carefully balanced and yet flamboyant composition. A few examples of works from this period that are still in Antwerp are: *The Scourging at the Pillar* [pp. 78–79], a gift to the Dominican church by a member of the Guild of Harquebusiers; *The Prodigal Son* [p. 41], a wonderful depiction of country life; *The Last Communion of St Francis of Assisi* [p. 38], purchased by a wealthy merchant for the chapel of St Francis in the church of the Friars Minor; and *Christ Crucified between the Two Thieves* ('The Lance') [p. 43], a work that Nicolaas Rockox commissioned for the high altar of the same church. A splendid example of Rubens's sense of dramatic expression is the series of tapestries of the life of Decius Mus. Rubens was commissioned to paint the designs for these seven tapestries by an Antwerp tapestry merchant and a Genoese nobleman at the end of 1616. Rubens first carried out sketches in oils on panel himself, after which he and his studio assistants transferred them to large canvases, producing cartoons that served as models for the weavers.

As mentioned earlier, it was particularly in the early years of the seventeenth century, when the threat of war had diminished in Antwerp, that religious art and architecture flourished. The clients wanted an art that expressed the triumphalist spirit of the Counter-Reformation. Baroque, which had entered the Spanish Netherlands under the impulse of Rubens, was pre-eminently suitable for that purpose because of its realism, decorative verve, monumentality and theatricality. The same style soon made its appearance in architecture too – in Rubens's own house, for example, but also and above all in church buildings. The first church in Antwerp to experience dynamic enlivening of the façade and its ornamentation was the Jesuit church (now St Charles Borromeo's, pp. 70–71). The ground plan was designed by the Jesuit François Aguilon, while the rest of the design of the building was in the hands of the Jesuit lay brother Peter Huyssens, in collaboration with Rubens. The artist not only played an important part in the design of the sculptural decoration of the façade and the interior, but he also produced several altarpieces and in 1620 he painted no less than 39 ceiling compositions within the space of a year, above all with the assistance of Antoon van Dyck. This work made the church a high point of Baroque art in the Netherlands. The paintings, which were set within wooden compartments in the ceiling, were destroyed by fire in 1718, but the oil sketches by Rubens on which they were based have survived. Seen from below with daring foreshortening, they show prophets and saints floating and engaging in activities in celestial spheres far above our heads. •

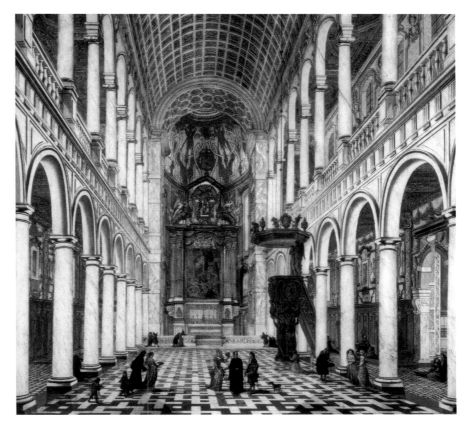

Willem van Ehrenberg, *Interior of the Jesuit church in Antwerp* (now St Charles Borromeo's church), 1668. Oil on marble, 97.5 × 103 cm. Antwerp, Rubens House.

Peter Paul Rubens, *Design Sketch for the Baldachin of the High Altar in the Jesuit church in Antwerp*, c. 1617. Oil sketch on panel, 44.5 × 64.8 cm. Antwerp, Rubens House.

Large-scale commissions and international renown

Between 1620 and 1628 Rubens's productivity reached a higher level than ever before. He designed a number of large series commissioned by princely courts. They displayed an exceptional technique in which colour and brushwork played a fundamental role.

Rubens's oeuvre shows a great diversity. His style continued to evolve as his career as an artist underwent various stages. From about 1620 onwards his brushwork and technique took yet another direction: he began to use a predominantly bright palette. He toned down the transitions from light to dark and worked much more with gradations and nuances within the same range of colours. *Disegno* and *colorito* are more or less combined in the rich, painterly chromatic gradations. This vision, already adumbrated in *The Lance*, is at one with the technique of the oil sketch, in which Rubens was extremely skilful.

The period running from about 1620 to 1628 can be called 'the period of the large-scale series', already anticipated in the series of paintings for the ceiling of the Jesuit church in Antwerp. At the same time, Rubens achieved a breakthrough in Europe, as within a brief period he received several large commissions from foreign courts for ensembles of paintings and designs for tapestry cycles. These were not his first foreign commissions, of course, but they were much larger and more numerous than in the past. For Maria de' Medici, the dowager queen of France, he painted 25 impressive canvases between 1622 and 1625 for

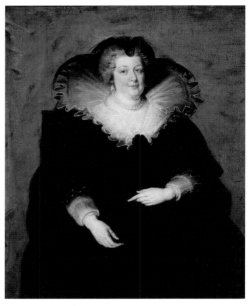

Peter Paul Rubens, *Portrait of Maria de' Medici*, 1622. Canvas, 130 × 108 cm. Madrid, Museo del Prado.

the decoration of the Palais du Luxembourg in Paris (now in the collection of the Louvre). He added the requisite lustre to her rather dull life by surrounding her with gods and heroes from classical antiquity. She issued a second commission, for a series on the life of her murdered husband, King Henry IV, but that ensemble was never completed. However, Rubens did design 12 tapestries illustrating the life of the Emperor Constantine for Louis XIII, her son. Around 1626–1627 he designed a series of 20 tapestries on the theme of the triumph of the Eucharist, a glorification of the Roman Catholic Church, for the Infanta Isabella. The series was woven in Brussels and was destined for the Descalzas Reales, a nunnery for discalced Carmelites in Madrid, where the archduchess had spent a part of her youth.

This was also the period in which Rubens produced a number of large altarpieces. Unity of composition is the characteristic of these breathtakingly beautiful works. The *perpetuum mobile* of oscillating movements and counter-movements of the numerous figures flows together to form a graceful synthesis. Rubens

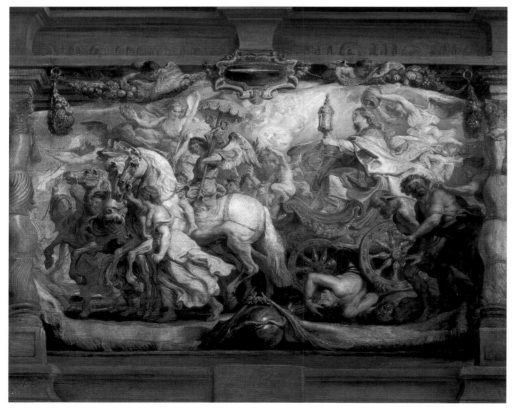

Peter Paul Rubens, *The Triumph of the Catholic Church*, c. 1626. Oil sketch on panel, 86 × 105 cm. *Modello* for one of the large tapestries of the series *The Triumph of the Eucharist*. Madrid, Museo del Prado.

achieved that coherence by means of an extremely variegated palette. *The Adoration of the Magi* [p. 44], a work that the artist painted for the high altar of the (no longer extant) abbey of St Michael in Antwerp, *The Assumption of the Virgin* from 1625–1626, which was painted for the high altar of the cathedral, and *Enthroned Madonna with Child, Encircled by Saints* [p. 47] from 1628, which graced the high altar of the church of St Augustine in Antwerp at the time, are three masterpieces of High Baroque art. *The Annunciation*, also known as *The Leganés Annunciation* [p. 86] after the Spanish marquis who purchased the work in 1628, was destined for the owner's private chapel and therefore has a more intimate, less heroic character in spite of the large format.

In the more painterly approach that characterises Rubens's work from about 1620 onwards, colour and brushstroke played a major role. That 'material' way of painting expresses, as it were, the artist's delight in working with brush and oils. The dazzling colours, nude bodies, luxuriant fabrics and lively movements are evidence of an artist with a colourful personality full of *joie de vivre*.

But these were difficult years for Rubens. The plague claimed many victims in Antwerp in the first decades of the seventeenth century. The Rubens family even left the city for a while in 1625 and went to live in Brussels. They returned to Antwerp in February 1626. This was when the plague struck: Isabella died at the age of 34 on 20 June 1626, leaving two sons, Albert and Nicolaas (the eldest child, Clara Serena, had already died at an early age). Peter Paul wrote to a friend: 'Today I have lost an excellent companion, whom one could love – indeed had to love, with good reason – as having none of the faults of her sex. She had no capricious moods, and no feminine weakness, but was all goodness and honesty. And because of her virtues she was loved during her lifetime, and mourned by all at her death.' During this period he worked on *The Assumption of the Virgin*, the altarpiece for the cathedral. He gave the female figure in red in the middle of the composition the features of Isabella.

In the same year he had problems with his health. During a trip to France in 1626 his foot had been in pain for a long time. It was probably an attack of gout, a complaint that was regularly to affect him later. •

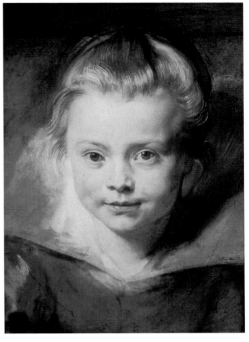

Peter Paul Rubens, *Clara Serena*, c. 1616. Panel, 33 x 26.3 cm. Vaduz, Sammlungen der Fürsten von Liechtenstein.

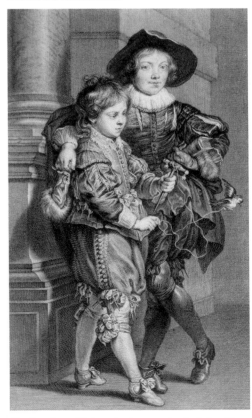

The Two Sons of Rubens, burin engraving by J. Daullé after Ch. Hutin after P.P. Rubens, eighteenth century. Antwerp, Rubens House.

Peter Paul Rubens, *The Assumption of the Virgin*, 1625–1626. Panel, 490 x 325 cm. Detail showing the woman pointing towards the tomb. Antwerp, Cathedral of Our Lady.

Political activities

Thanks to his good contacts with the princely courts of Europe, his erudition, and his charming character, Rubens was appointed as an informal international negotiator, and in that capacity he laid the foundations for the peace talks between Spain and England. His diplomatic efforts won him a good many commissions for portraits of princes and other high-ranking dignitaries, while in the meantime his oeuvre was disseminated through the engravings that his assistants made of his works.

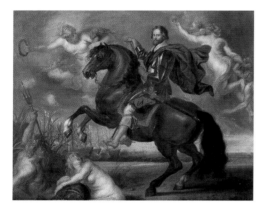

Copy after P.P. Rubens, *Triumph of the Duke of Buckingham.* Canvas, 84.7 × 103.8 cm. Antwerp, Rubens House.

The international political prospects looked poor because France and England, who wanted to break Spain as a world power, intervened in the situation. After a meeting with the Duke of Buckingham and the latter's representative, the painter Balthasar Gerbier, in Paris in 1625, Rubens was finally successful in getting official diplomatic activities at a European level under way. As a result, his trips became more frequent after 1626. They offered him a welcome diversion after the death of his wife. He entrusted the supervision of the studio to a former pupil and the upbringing of his two sons to a friend, Jan Gaspar Gevartius. In 1628

he travelled to Madrid, where he was to spend some eight months before being dispatched from there to London on a peace mission. The Duke of Buckingham had been murdered in the meantime, but Rubens nevertheless took great effort in laying down the bases for peace talks between Spain and England. The English king subsequently appointed an ambassador to Madrid, while his Spanish counterpart did the same to London. Rubens's mission was now complete. After Charles I of England had knighted him as a token of appreciation of his peace efforts, Rubens returned to Antwerp in April 1630. That was the year in which the splendid *Self-Portrait* [p.95] was painted, in which the gently expressive face with the white collar stands out against a brown background, a black hat and a dark doublet.

Rubens's diplomatic missions were not without importance for his art. In Madrid he did portraits of Philip IV and members of the royal family, and in London his paintings for Charles I included *The Allegory of Peace.* The king of England also entrusted him with a large-scale commission to be carried out

After the death of Isabella Brant, Rubens travelled a good deal, even more than he had done before. He had spent several months at the French court in the first half of the 1620s, in connection with the series of paintings for Marie de' Medici and other matters. Moreover, after the death of the Archduke Albrecht in 1621, Rubens had become the political counsellor of the governor, Isabella. She and her close associate, General Ambrogio Spinola, placed great confidence in him, and after the expiry of the Twelve Years Truce in 1621 they involved him in negotiations that were intended to result in a new truce or a permanent peace treaty with the North Netherlands. The threat of a resumption of hostilities in the Netherlands, the lack of official diplomatic channels, and the opposition to attempts to establish peace from the highest circles in both camps had all led to the governor's decision to bring in informal secret negotiators.

Peter Paul Rubens, *Minerva and Hercules Combat Mars*, c. 1630. Oil sketch on panel, 35 × 53 cm. Antwerp, Royal Museum of Fine Arts.
The posture of Mars and Minerva as opponents is taken from *The Allegory of Peace.*

in Antwerp: paintings on canvas for the ceiling of the Banqueting Hall of the Palace of Whitehall in London. This work was not completed until 1634–1635. During his stays at the courts of Madrid and London, Rubens came into contact again after a long time with the style of Titian, as the two royal collections contained many works by the Venetian master. This renewed acquaintance influenced Rubens's style after 1628 and continued to affect him in his *ultima maniera*, the final stage of his artistic development. From 1628 onwards his style evolved towards lighter and softer colours with subtle variations in between, and towards less clear figural contours modelled in a softer manner. An even freer, more flowing brushstroke than before gives the compositions a spontaneous and direct, almost 'Impressionist' character.

Rubens's artistic activities were not confined to painting. He also had an enormous influence on seventeenth-century printmaking (burin engraving and woodcuts). Several engravers in his circle were intensively occupied in reproducing the master's creations

Landscape with Stables, burin engraving by Schelte à Bolswert after P.P. Rubens, 1630s (?). Antwerp, Rubens House.

with the burin. Rubens owed his fame to some extent to the many prints that were issued under his own supervision and that spread his style all over Europe. He supervised the entire process of production in person, retouched the engravers' sketches, and even the proofs. He imposed high demands on the skill of the engravers, whom he trained himself. The graphic reproductions of his paintings or original designs are faithful to his compositions,

The Drunken Silenus, woodcut by Christoffel Jegher after P.P. Rubens, later than 1630. Antwerp, Rubens House.

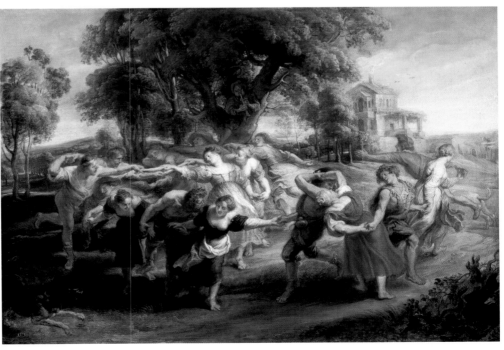

Peter Paul Rubens, *Peasant Dance*, c. 1635. Panel, 73 x 106 cm. Madrid, Museo del Prado.

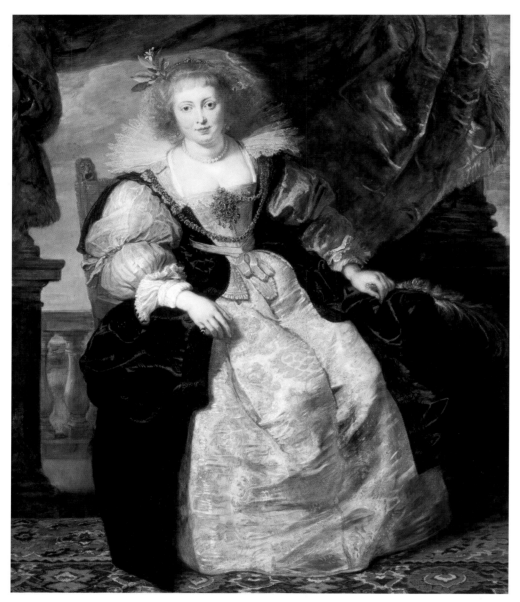

was the 16-year-old Helena, the daughter of the tapestry merchant Daniël Fourment, a friend of the artist. 'I have taken a young wife of honest but middle-class family, although everyone tried to persuade me to make a Court marriage. But I feared pride, that inherent vice of the nobility, particularly in that sex, and that is why I chose one who would not blush to see me take my brushes in hand. And to tell the truth, it would have been hard for me to exchange the priceless treasure of liberty for the embraces of an old woman', Rubens wrote to Nicolas-Claude Fabri de Peiresc a few years later.

In that same year the political and military situation in the Netherlands became extremely tense. The war of religion had turned into a general European conflict with intertwined political and economic interests and shifting alliances, which virtually ruled out the possibility of a peaceful solution by diplomatic means. Rubens tried once again to pave the way for a peace between the Republic in the North and the Spanish Netherlands, but the negotiations came to nothing. That disillusionment, no doubt his recent second marriage too, and the death of Archduchess Isabella in 1633, all contributed to his decision to abandon diplomacy for good. •

Peter Paul Rubens, *Helena Fourment in Wedding Dress*, c. 1630–1631. Panel, 163.5 x 136.9 cm. Munich, Alte Pinakothek.

including his Baroque bravura and the gradations of light and colour, which are translated into the black and grey nuances of the medium. Rubens designed frontispieces and illustrations for Balthasar I Moretus (1574-1641), who was in charge of the printing works The Golden Compasses (Officina Plantiniana) in Antwerp, and occasionally also for other printers, thereby introducing the Baroque style into book illustration. His contribution to the art of the tapestry has already been mentioned. In addition, through his interest in sculpture, his friendship with various sculptors, and his own sculptural designs, he exerted a very strong influence on the development of Baroque sculpture and ivory carving in Flanders. And the Baroque ornamentation favoured by Rubens also entered the field of architecture via Hans van Mildert (1585-1638) and many other sculptors in Antwerp and elsewhere.

Rubens remarried in December 1630, four years after the death of his first wife. His bride

The lyrical period

During the last years of his life, Rubens no longer had to prove himself. His art was known in the furthest corners of Europe, he had been knighted, and could rely on more than skilled assistants. His style became more lyrical and expressed the calm, prosperity and happy years that he now experienced.

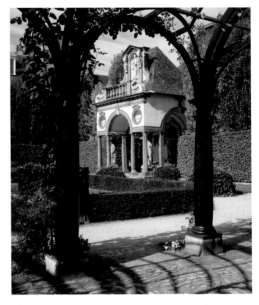

The garden of the Rubens House with view of the rear of the Italian façade and the portico.

Life became calmer for Rubens now that the period of the long journeys was over. Helena bore him five children. He lived with his family as a well-to-do resident in his native city and dedicated himself with unflagging energy to his painting. His productivity remained high, thanks to the smoothly running studio. After 1630 he seems to have suffered regular attacks of gout, which sometimes prevented him from working, so that some of the tasks that he had been used to carrying out himself, such as retouching the copper plates of the engravers and elaborating book illustrations, had to be delegated to his assistants.

Roger de Piles describes Rubens's day as follows: 'He rose every morning at four o'clock and always began his day by attending Mass, at least unless he was prevented by the gout which seriously bothered him. Afterwards he got down to work, always with a reader nearby, whom he paid to read aloud from some good book or other, usually Plutarch, Livy or Seneca. Because he very much enjoyed working, he organised his life in such a way that he could do so easily and without putting his health at risk; that is why he ate very little at noon [...]. He worked thus until five o'clock, after which he took a ride outside the city or on the city ramparts on horseback, or did something else to relax his mind. When he returned from his ride, he usually found some of his friends in his house who had come to join him in the evening meal. Nevertheless, he disapproved of excessive drinking and eating, and also of gaming. He took the most pleasure in riding a fine Spanish horse, reading a book, or examining and studying his medals, his agates, carnelians or other cut stones, of which he possessed a wonderful collection.'

In 1633 Rubens became dean of the Antwerp Guild of St Luke. As was customary, he received a leather-upholstered walnut chair of his own with his name and the guild device, but he left the exercise of the function to his friend the sculptor Hans van Mildert. In 1635 he purchased a country house, Het Steen, near Elewijt, and from then on he spent the summer months there with his family. Having been knighted by the king of England in 1630 and ennobled by the Spanish king in the following year, he could lay claim to the title 'Lord of Steen'. He painted the gently rolling Brabant countryside around Het Steen in landscapes that radiate something visionary, something of a cosmic inspiration. The Hof van Ursel in Ekeren, a *villa rustica* that he had bought in 1627, was also the subject of a painting. The castle grounds in Ekeren are the setting for a group of people engaged in carefree play in a rural setting with a castle.

But the most rewarding source of inspiration for Rubens at this time was his young wife. With her youthful beauty, she was his favourite model for female figures in biblical, allegorical and mythological scenes, and he painted wonderful portraits of her. His last stylistic period, the 1630s, is usually referred to as the 'lyrical' period. The number of altarpieces and monumental works decreased.

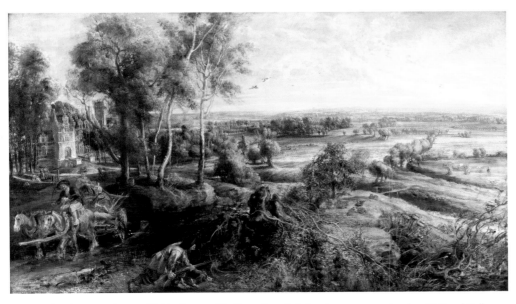

Peter Paul Rubens, *Landscape with Het Steen at Elewijt*, c. 1635–1638. Panel, 131 x 229 cm. London, National Gallery.

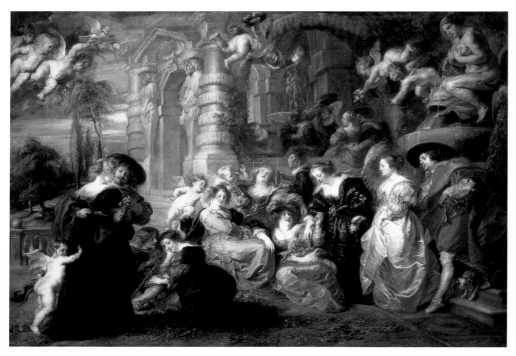

Peter Paul Rubens, *The Garden of Love*, c. 1631–1632. Canvas, 198 x 283 cm. Madrid, Museo del Prado.

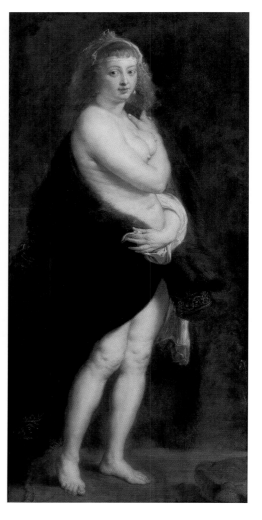

It seems as though the artist now took on fewer commissions than he had done in the past in order to be able to dedicate himself to themes that held his attention and in which he took a personal pleasure. With great tenderness he painted sensual female nudes or mythological figures in an Arcadian setting, as well as splendid portraits and rolling landscapes. Works from this period include *Portrait of Helena Fourment ('The Fur')* and several other

> Peter Paul Rubens, *Portrait of Helena Fourment ('The Fur')*, c. 1638. Panel, 176 x 83 cm. Vienna, Kunsthistorisches Museum.

Specialisation and collaboration among the artists of Antwerp

Peter Paul Rubens, *Prometheus Bound*, detail, c. 1611–1612, completed by 1618. Canvas, 243 x 210 cm. The Philadelphia Museum of Art.

Most Antwerp painters were specialists in one or several genres, in which they often attained an unsurpassed quality. Throughout his entire career Rubens called in those colleagues now and then – Jan Brueghel I ('Velvet' Brueghel), Frans Snyders, Paul de Vos, Jan Wildens and others – to add certain elements to one of the works under his direction. He made no attempt to disguise the fact: 'Panthers [...] Original from my hand, except the beautiful landscape by a specialist in this material' or 'Prometheus in chains on Mount Caucasus [...] Original from my hand and the eagle done by Snyders'. The unfinished canvas *Henry IV in the Battle of Paris* [p. 88] is an example of such a collaboration. The collaboration also took place in the reverse direction when Rubens contributed as the 'figure painter' to compositions by artist friends. A specification along these lines for a number of paintings from his collection is provided in the inventory compiled after his death, such as 'A huntinge of Diana; the figures of Sr Peter Rubens – The Landschaps and the beasts of Brueghel'.

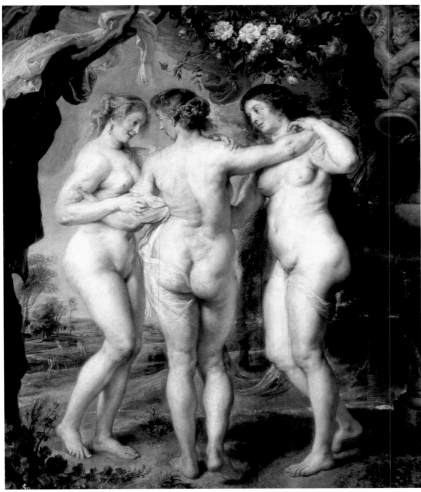

Peter Paul Rubens, *The Three Graces*, 1639. Canvas, 221 x 181 cm. Madrid, Museo del Prado.

Peter Paul Rubens, *The Arch of the Mint (front)*, 1635.
Oil sketch on panel, 104 x 71 cm.
Antwerp, Royal Museum of Fine Arts.

portraits of his second wife, sometimes with her children, *The Three Graces, Landscape with Het Steen at Elewijt*, and *Landscape with a Rainbow*. The painting *The Garden of Love* is the perfect expression of Rubens's happiness after his wedding. A group engaged in flirtatious activity, spurred on by *putti*, are dallying in a delightful garden near a fountain of love.

In the meantime, of course, the artist continued to carry out large-scale commissions just as before. In 1634 the city of Antwerp asked him to design the triumphal arches for the Triumphal Entry of the new governor of the South Netherlands, Cardinal-Infante Ferdinand, a brother of King Philip IV. Rubens made all the oil sketches, flamboyant and grand decorative architectural forms in har-

mony with the grandiose character of the event. A group of Antwerp painters used these sketches as the model for the canvases with which the triumphal arches were decorated. The Pompa Introitus Ferdinandi was held in April 1635. Two of Rubens's designs, those for the front and rear of the Arch of the Mint, have been preserved.

The major undertaking of Rubens's last years, in fact the largest commission that he ever received, was the ensemble of more than one hundred mythological and hunting scenes to be delivered in 1636–1638, with the help of his assistants, for the decoration of the Torre de la Parada, the new hunting lodge of the Spanish king on the outskirts of Madrid. Rubens himself executed some fifty oil sketches

(for the mythological scenes) and four canvases of the series, while the rest were done by Jacob Jordaens, Cornelis de Vos, Theodoor van Thulden, Erasmus Quellinus and other artists from his entourage; Frans Snyders and Paul de Vos designed the hunting scenes. Rubens's oil sketches display an astonishing virtuosity in their imaginative but sure execution, with a sparing use of resources – a few strokes of the brush and a couple of dashes of colour suffice to bring the whole composition into being. The same fluid technique recurs in *The Triumphal Chariot of Kallo* [p. 49] of 1638 and in the sketches for *The Rape of the Sabines* and *The Reconciliation between Romans and Sabines* of 1640.

Rubens executed the commission for the Pompa Introitus of the governor and that for the Torre de la Parada in collaboration with his most skilled colleagues. Such an organisation of work was by no means unusual in the circle of artists in Antwerp. It was not only pupils and assistants who worked in the studio; fully trained masters worked there too. The distribution of a large-scale commission, such as the large series of paintings mentioned

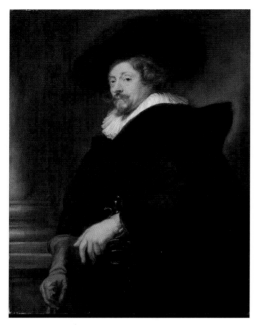

Peter Paul Rubens, *Self-Portrait*, later than 1635.
Canvas, 109.5 x 85 cm. Vienna, Kunsthistorisches
Museum.

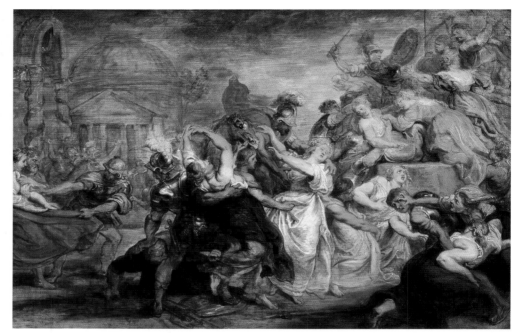

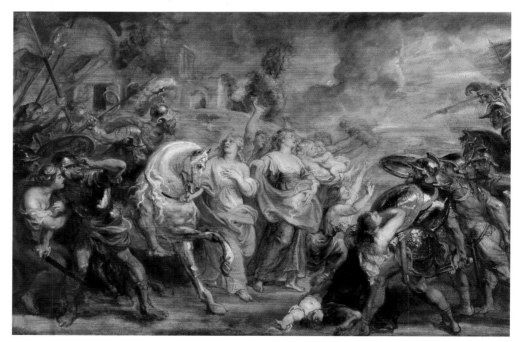

Peter Paul Rubens, *The Rape of the Sabines* and *The Reconciliation between Romans and Sabines*, 1640.
Oil sketches on panel, 56 x 87 cm and 55.5 x 86.5 cm. Antwerp, Osterrieth House.
The paintings based on the oil sketches were destroyed in a fire. The underlying themes in these scenes illustrating
a Roman legend are Fertility and Peace, two fundamental notions in Rubens's art.

above, among colleagues was necessary in order
to be able to deliver the work on time or within
an acceptable period of time. But there was an
even more intensive form of collaboration: two
(or more) artists who worked on one and the
same painting that bore both of their names.

Not only did Antoon van Dyck work as a
studio assistant in the Rubens House, but the
other famous Baroque painter from Antwerp,
Jacob Jordaens (1593–1678) also collaborated
with Rubens now and then. Although Jor-
daens had never been a pupil of Rubens, he
looked up to the great master in his early years
and wanted to imitate his heroic style. Later
on he developed a style that reflected his own
temperament, more down to earth and crude,
possibly due to the fact that he had never vis-
ited Italy. He owes his reputation above all to
genre paintings such as *The King Drinks* and *As
the Old Sing, So the Young Pipe*. His forcefully
rendered figures, bathed in a deliciously warm
light, radiate *joie de vivre* and sensuality. After
the death of Rubens in 1640 and of van Dyck in
1641, Jordaens became the leading painter in
the South Netherlands.

Peter Paul Rubens died in his Antwerp
home on 30 May 1640. In accordance with his

wishes, a painting that he had completed
during the last years of his life, *Our Lady, the
Christ Child and Saints* [p. 85], was hung above
the altar of the chapel in the church of St
James, where his remains were buried. This
scene, a *sacra conversazione* between Mary and

the Christ Child and a group of saints, is an
example of the virtuoso style of painting and
the warm tonalities of the 'lyrical period' and
radiates the gentle light that confers a para-
disaical sheen on so many of his paintings. •

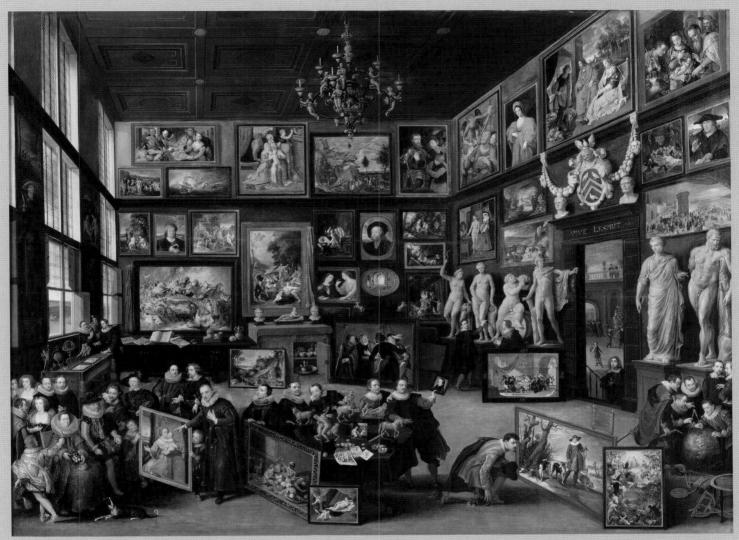

Willem van Haecht, *The Picture Gallery of Cornelis van der Geest*, 1628. Panel, 100 x 130 cm. Antwerp, Rubens House.

Peter Paul Rubens and Antwerp are united, as it were, in the painting *The Picture Gallery of Cornelis van der Geest*. This work represents the private collection of the wealthy Antwerp merchant and art-lover Cornelis van der Geest, a friend of Rubens.

Paintings of this kind were a typical Antwerp phenomenon in the seventeenth century. The well-to-do owners of collections were so proud of their artistic treasures that they had them perpetuated in a painting down to the smallest detail. Van der Geest had one of the most impressive collections in the city. Among the works depicted are several very famous ones, including a panel by van Eyck, a few works by Quinten Metsys, a landscape by Pieter Bruegel the Elder, two large works by Rubens (*The Battle of the Amazons* and *An Army Commander with Two Pages*), and many other paintings by contemporaries.

But it is not just the works of art and other objects depicted in it that make this panel so unique. Represented in the painting are many individuals who played leading roles in the cultural life of Rubens's day. Van der Geest stands as the proud owner of the precious collection and as host among friends and prominent Antwerp artists, while his house is honoured with high-ranking visitors: the painting records a historical event, namely the visit by the Archduke Albrecht and Archduchess Isabella in 1615 on the occasion of a tournament on the water, which they watched from his home overlooking the River Schelde. However, Willem van Haecht completed the painting in 1628, many years after that celebrated event, and the picture that he presents is not historically correct. Some of the paintings depicted in his work were not yet in the collection in 1615, and some of the individuals represented

could not have been there in 1615 either...

The archducal couple are seated on the left, surrounded by an entourage of courtiers, ladies in waiting and counsellors. Behind them stands the mayor, Nicolaas Rockox. The man who bows towards the governor and seems to be engaged in conversation with him is Rubens; his position beside the archduke alludes to his relation to the court. To his rear is Antoon van Dyck, next to the host, who entertains the archduke and his wife with a painting of the Madonna. The other figures are mainly painters, sculptors and collectors. In many cases Willem van Haecht drew on portraits by Van Dyck to represent the assembled company.

The inscription above the door embodies the view of life of Cornelis van der Geest, Peter Paul Rubens and their like-minded friends: 'Vive l'Esprit'.

Royal Museum of Fine Arts

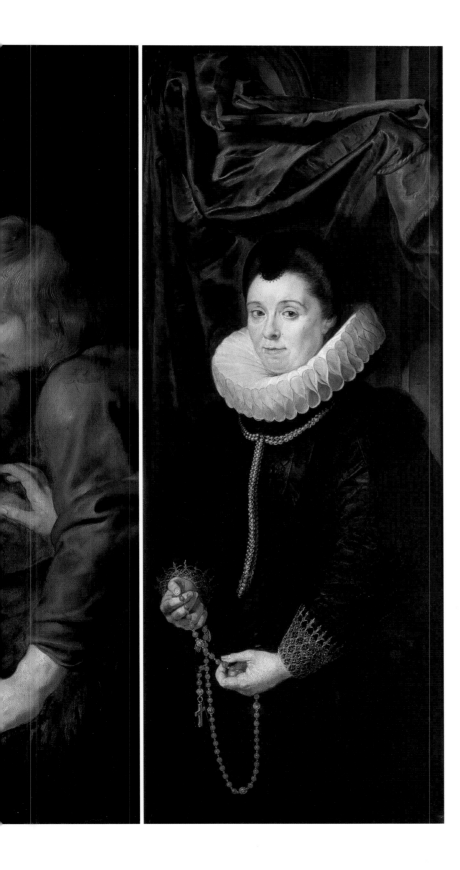

Rubens painted this triptych for his friend Nicolaas Rockox (1560–1640), mayor of Antwerp. He depicted his patron on the left-hand panel and his wife Adriana Perez (?–1619) on the right-hand panel. The work was commissioned for the future burial place of the couple in a chapel of the church of the Friars Minor. In *The Incredulity of St Thomas*, Rubens evokes an episode from the New Testament when the resurrected Jesus appears to the disciples and shows them his wounds as proof that he really has risen from the dead. This was an appropriate theme for a funerary chapel.

Venus Frigida 1614
Panel, originally 121 x 95 cm, enlarged to
142 x 184 cm (first half seventeenth century)
The landscape is by a different artist

For this illustration of the quotation 'Sine
Cerere et Libero friget Venus' (Love freezes
from Hunger and Thirst) from the Roman
comic writer Terence, the artist drew his
inspiration from an ancient marble statue
of Venus that he had seen in Rome. An
apathetic Venus is accompanied by her
young son Amor, who is shivering with
cold. A satyr with a cornucopia laden with
grapes, grain and fruit tries to attract their
attention. The work is typical of Rubens's
'classical' period. The painting was
enlarged at the top and on the right with
a narrow strip and on the left with a wide
panel, possibly still in Rubens's time; the
entire landscape background was added
by a different artist at that time.

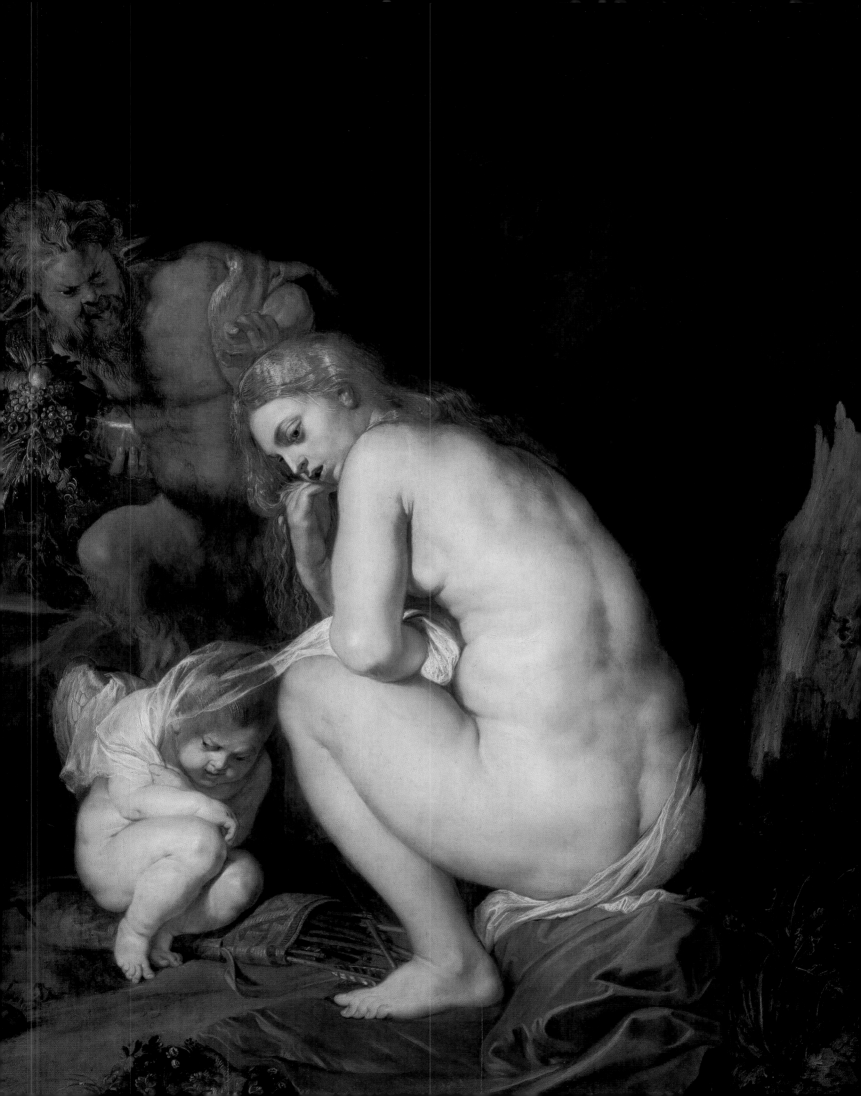

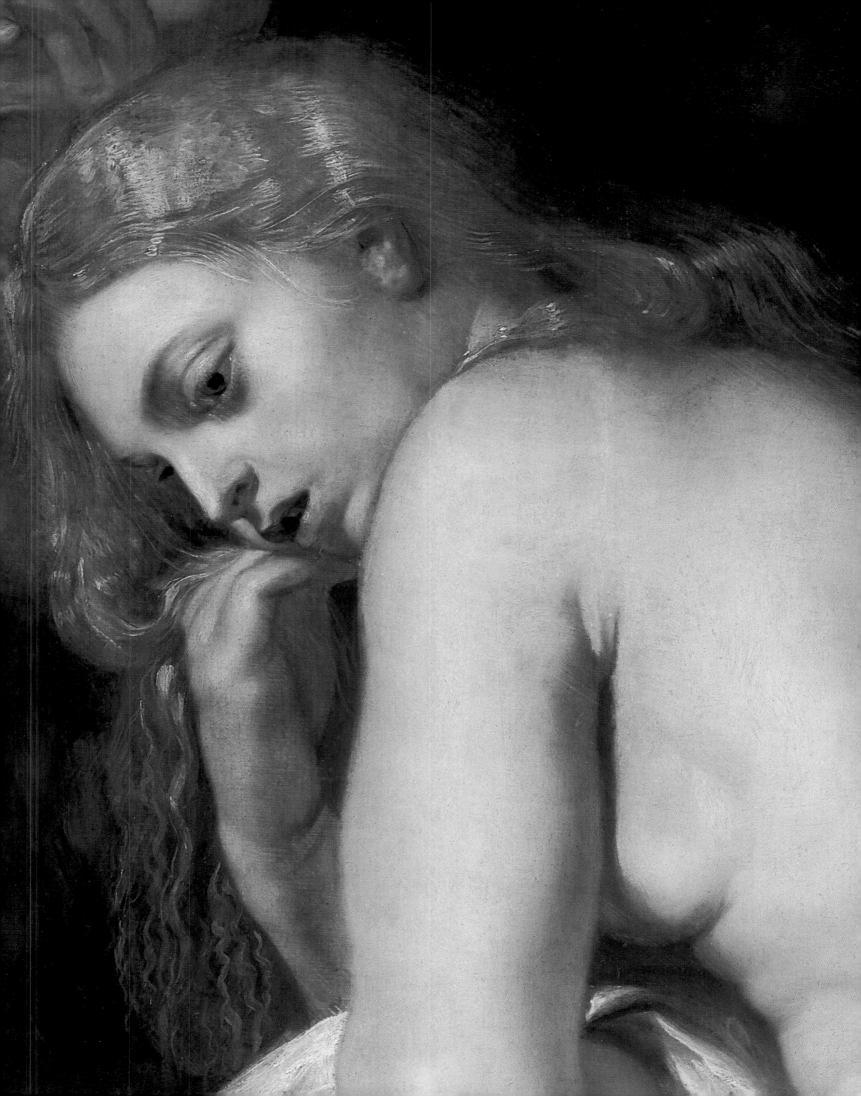

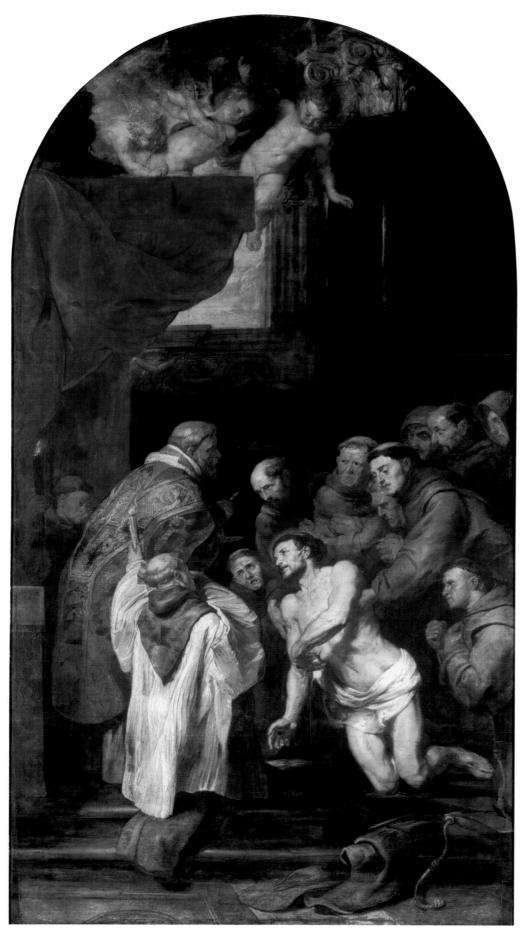

The Last Communion of St Francis of Assisi 1618–1619
Panel, 422 x 266 cm
Altarpiece in the church of the Friars Minor in Antwerp

This painting was commissioned by a rich merchant, who donated it to the church of the Friars Minor (an order of Franciscan monks) in Antwerp. That is why the painting depicts a scene from the life of St Francis of Assisi. Rubens rendered the subject with gentle transitions from light to dark, and with an intense feeling in the gestures and facial expressions of the monks. The window behind the baldachin appears to reveal a part of the sky. The fact that the saint is surrounded by twelve persons may refer to his association with Christ, on whom St Francis deliberately modelled himself. Scenes from the Passion were therefore a popular subject for the decoration of churches of the Franciscans and Friars Minor.

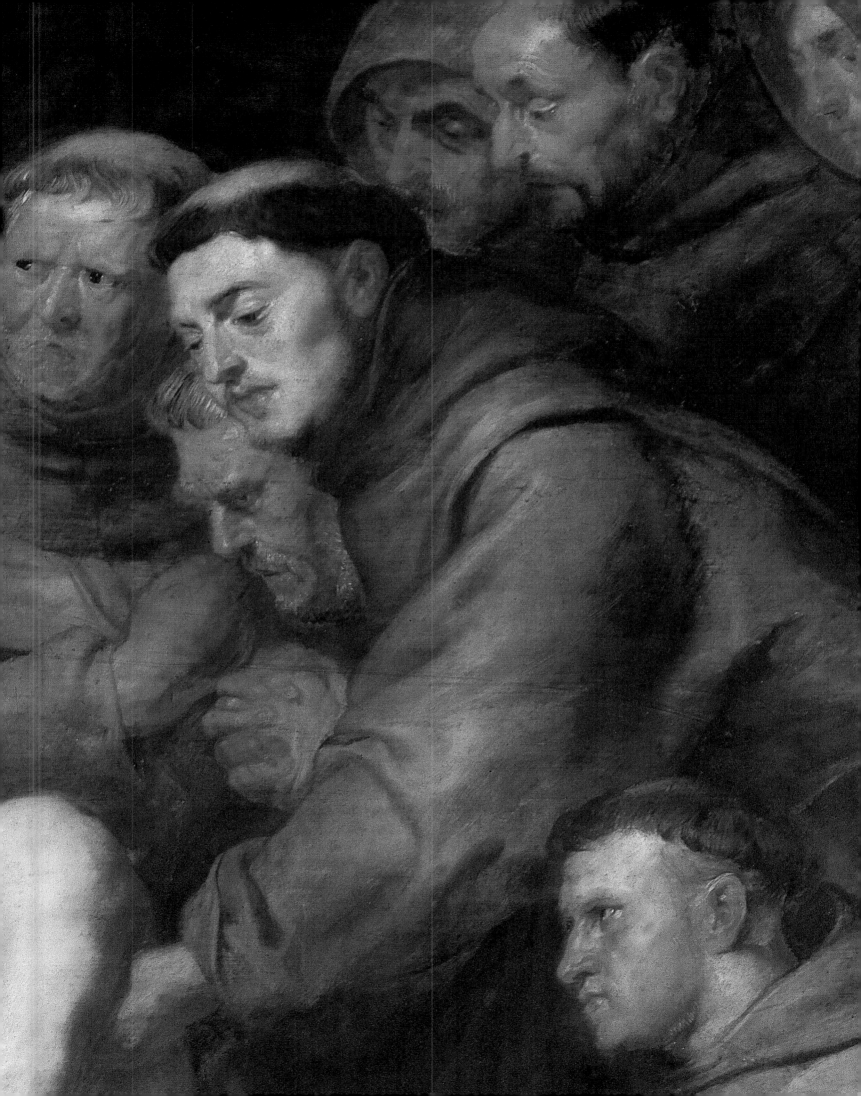

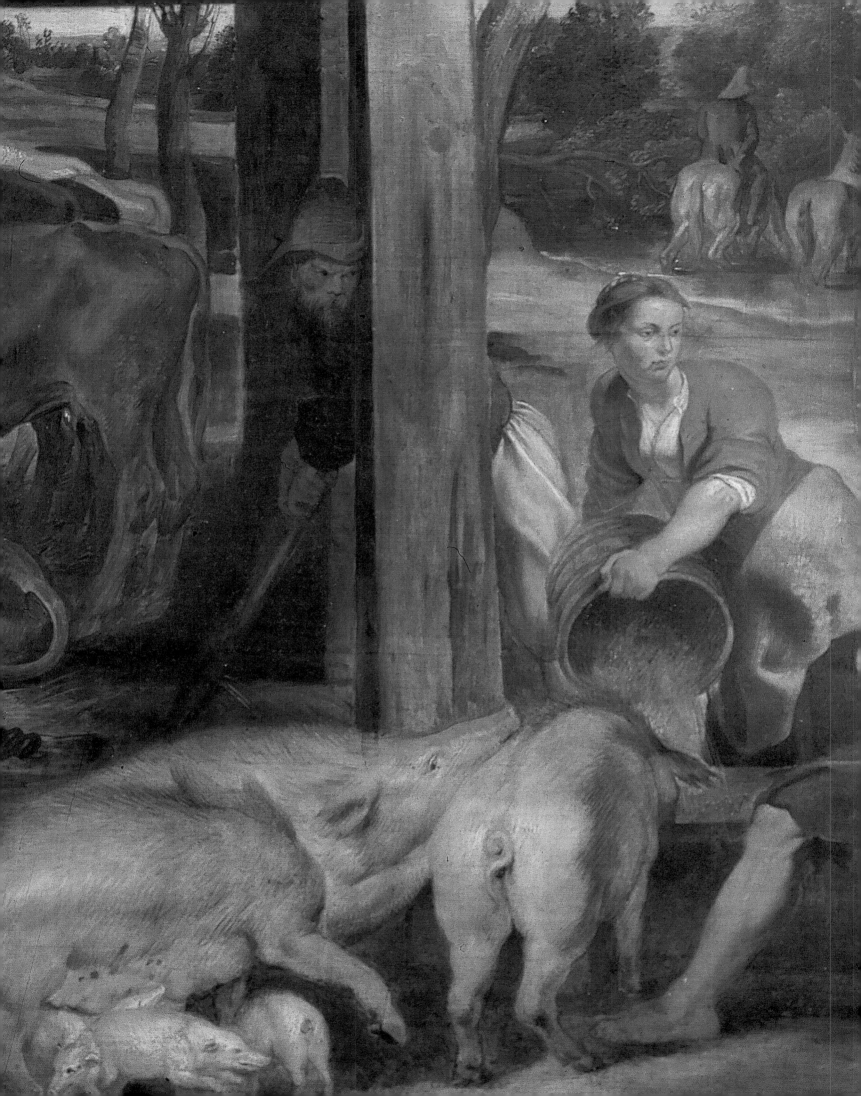

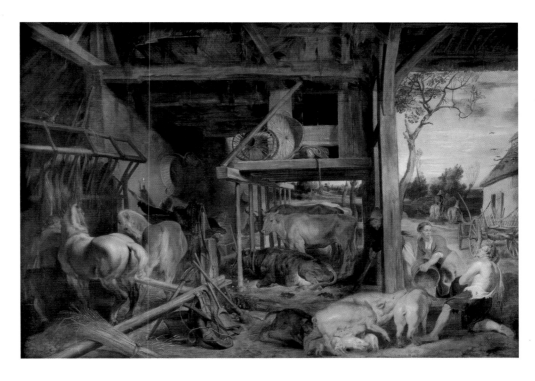

The Prodigal Son 1618
Panel, 107 x 155 cm

Like just a detail in the composition, the prodigal son is sitting in a corner begging for food, while a young peasant girl fills a trough with pig feed. In fact the religious theme is secondary. The New Testament parable about a dissolute young man who falls into harsh poverty led Rubens to create one of his most beautiful scenes of country life. *The Prodigal Son* must have been one of his favourite paintings; the panel was still in his possession when he died.

Thanks to the generosity of a few rich citizens, several works by Rubens hung in the church of the Friars Minor. *Christ Crucified between the Two Thieves* was commissioned by Nicolaas Rockox. The central theme of the highly dramatic composition refers to the spiritual nature of the Friars Minor, whose founder St Francis had mystically received the five stigmata of Christ (the wounds in the hands, feet and side).

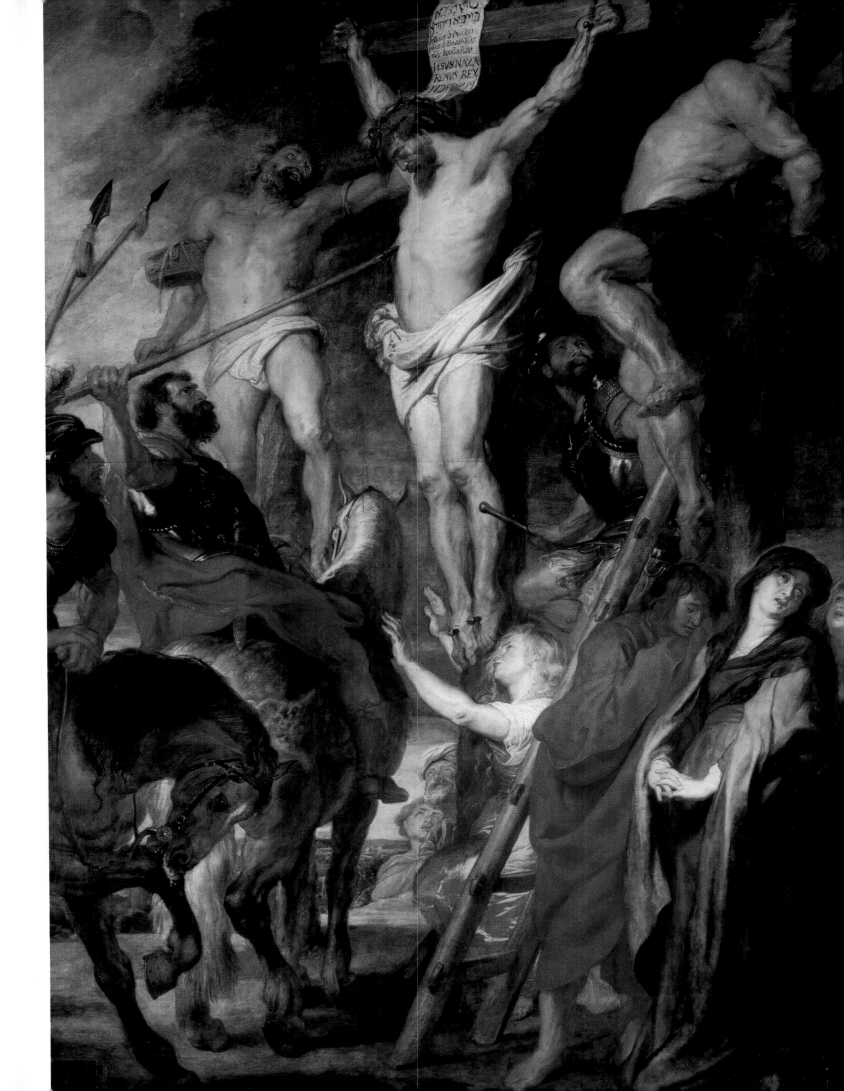

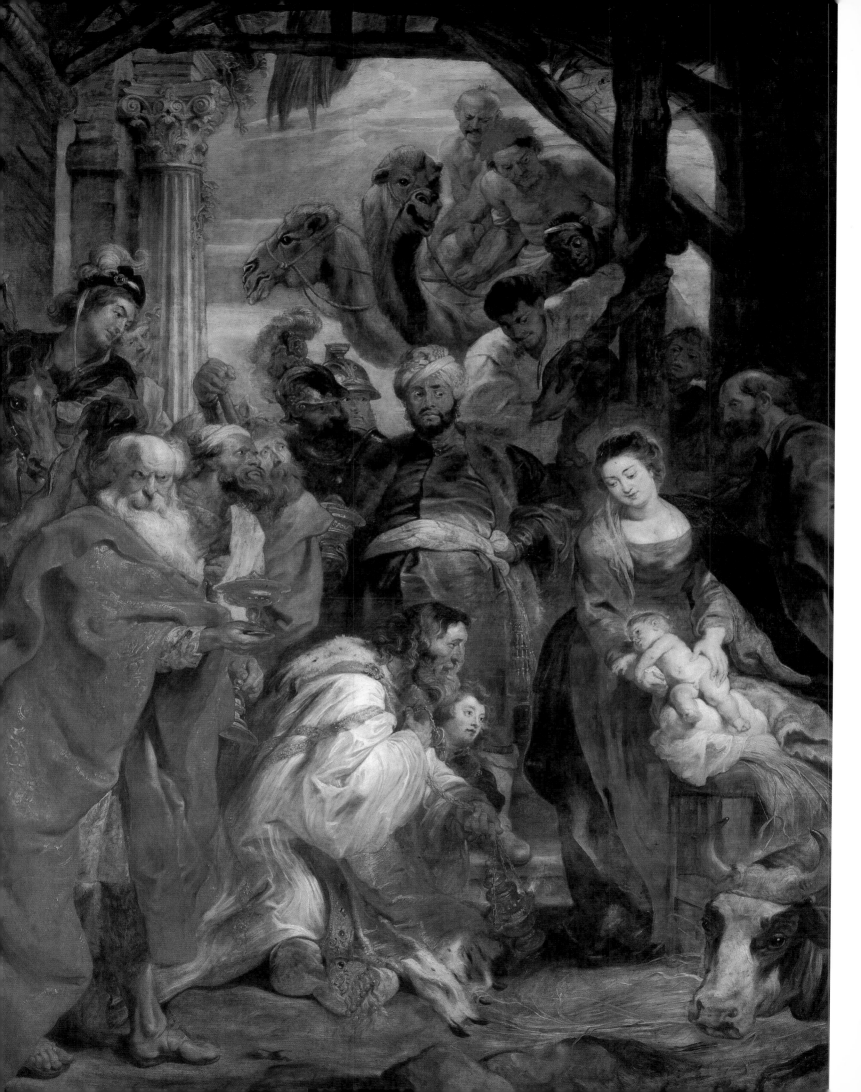

The Adoration of the Magi 1624
Panel, 447 × 336 cm
Altarpiece of the high altar in St Michael's Abbey
in Antwerp

The Adoration of the Magi is considered to be one of Rubens's most beautiful altarpieces. It is a full-blown expression of High Baroque. The work impresses with its lively, asymmetrical composition, the richly variegated palette, the ease of the brushwork, and the expressiveness of the figures. The highly differentiated and restless group is held together, as it were, by a few strong vertical architectural elements, a horizontal beam at the top, and a few diagonal beams that follow the main lines of the composition. This monumental panel is also exceptional in terms of technique: in some parts of the composition, Rubens creates forms on the light ochre background with a few broad brushstrokes – for example, in the lower right, with the cow's head and the straw on the floor. He is here applying the technique of the small oil sketch to a large format. According to tradition, he completed the work in two weeks. The sure, virtuoso brushwork and the sparing use of paint make that story highly credible. The altarpiece originally hung in the church of the extremely powerful Abbey of St Michael, which disappeared at the beginning of the nineteenth century.

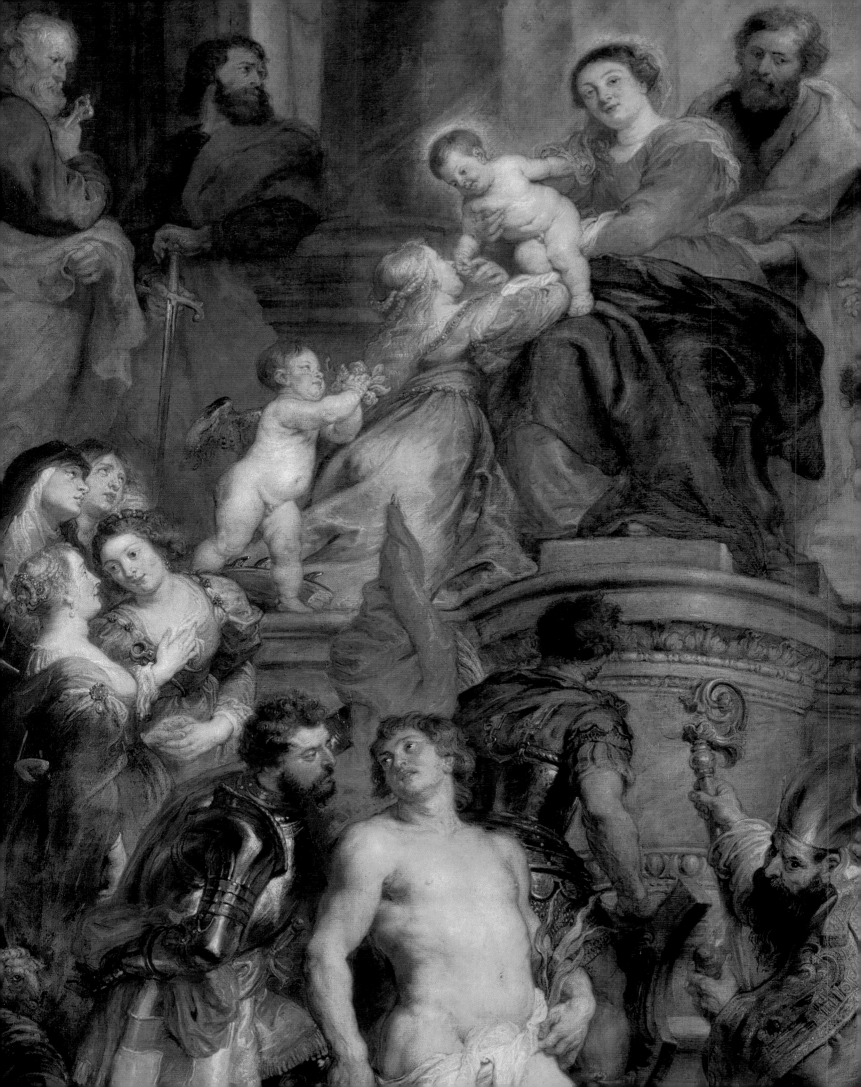

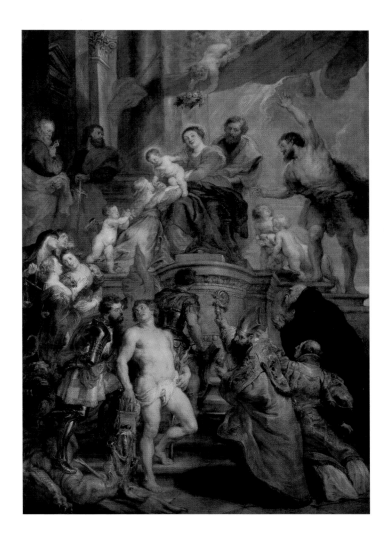

Enthroned Madonna with Child, Encircled by Saints 1628
Canvas, 564 x 401 cm
Altarpiece for the high altar in St Augustine's church, Antwerp

A company of male and female saints is gathered around the
Holy Family. Only two figures look in the direction of the
viewer: the enthroned Madonna, the purpose and climax of
the procession, and the imposing figure of the bishop at the
bottom of the staircase, holding a crosier and a burning heart.
This is St Augustine. He seems to be gesturing to the faithful
to focus their attention on the enthroned Madonna who is
about to be crowned Queen of Heaven by an angel.

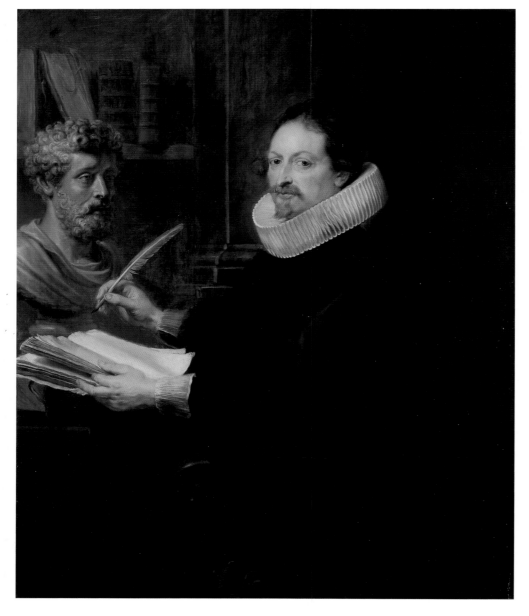

Portrait of Jan Gaspar Gevartius c. 1628
Panel, 119 x 98 cm

Jan Gaspar Gevaerts (Latinized as Gevartius) was holder of a public office (*stadsgriffier*) in Antwerp. He is appropriately shown with a pen and register at his desk. The marble bust in the background is of the Roman emperor and philosopher Marcus Aurelius, whose works were studied and commented on by Gevartius. The subject of this portrait was a good friend of Rubens. That personal connection appears to be suggested by the relaxed pose of Gevartius, as though he is glancing up from his book for a moment to converse with the painter who has come to pay him a visit in his study.

> *The Triumphal Chariot of Kallo* 1638
Panel, 103 x 71 cm
Oil sketch

When the armies of the Spanish governor Cardinal-Infante Ferdinand won a victory over the Dutch and French in Kallo (near Antwerp) and in Saint-Omer (French Flanders) in 1638, the city of Antwerp decided to celebrate the commander's achievement. It commissioned a design for a triumphal chariot from Rubens. The chariot is conceived as a ship with all kinds of allegorical female figures, including Prosperity, Providence, Courage, the city virgins of Antwerp and Saint-Omer, and, on a socle, Victory as two winged virgins with floral garlands and a medallion with an inscription. This rapidly executed design in oils illustrates Rubens's consummate sketching technique.

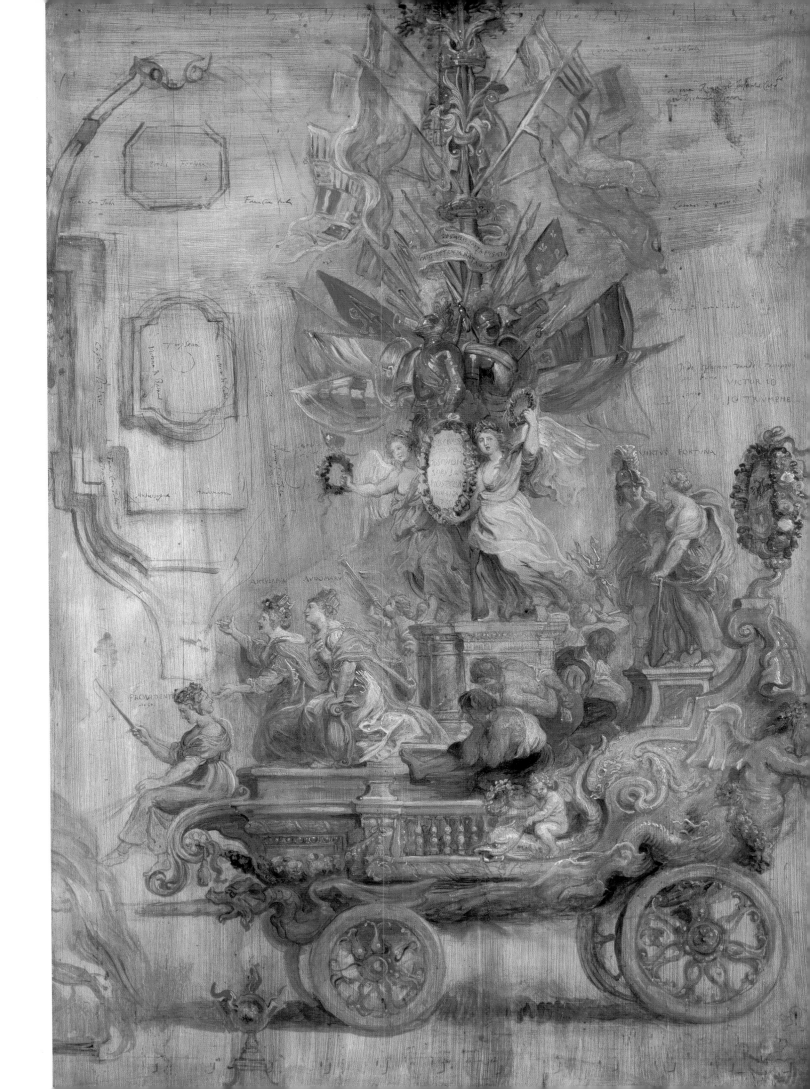

Plantin-Moretus Museum and Municipal Print Cabinet

The Polish Jesuit Mathias Casimir
Sarbievski was a well-known poet in Latin.
The various elements of the illustration
for the title page refer to the art of poetry,
on the one hand, and to the person to
whom Sarbievski dedicated his collection
of verse, on the other. Poetry is symbolised
by two figures: a Muse on the left and
Apollo, the god of music and poetry, with
his lyre, the instrument of singers, on the
right. The Muse has a child with her,
around whom some bees are flying. This
might be an allusion to the great Greek
poet Pindar, who, according to legend, was
fed in the cradle with honey by the bees.
But these bees have further significance.
The collection of poems was dedicated to
Pope Urbanus VIII (Maffeo Barberini). That
is why the papal insignia of the tiara and
keys of St Peter are shown above a shield
that is empty in the preliminary drawing
but contains the image of three bees – the
device of the Barberini family – in the final
copper engraving. Five years later the
engraver Cornelis Galle's copper plate was
reused, but with a different inscription, as
the title page for a book about Pope
Urbanus VIII.

Title page design for *Maffeo Barberini, Poemata*
Paper, pen and brown ink on a preliminary drawing
in black chalk, 17.9 x 13.8 cm

Maffeo Barberini, who became Pope
Urbanus VIII in 1623, was a connoisseur of
the fine arts and a poet of considerable
skill. Rubens's sketch represents the con-
tent of one of the poems from the collec-
tion: Samson sees honey in the jaws of a
lion. The bees that emerge from the jaws
refer to honey but also to the three bees of
the Barberini family device.

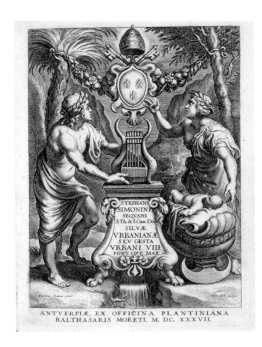

Title page of Mathias Casimir Sarbievski,
Lyricorum libri IV, Antwerp, Officina Plantiniana
of Balthasar I Moretus, 1632
Cornelis I Galle 1576–1650
Copper engraving after the design by P.P. Rubens

Cathedral of Our Lady

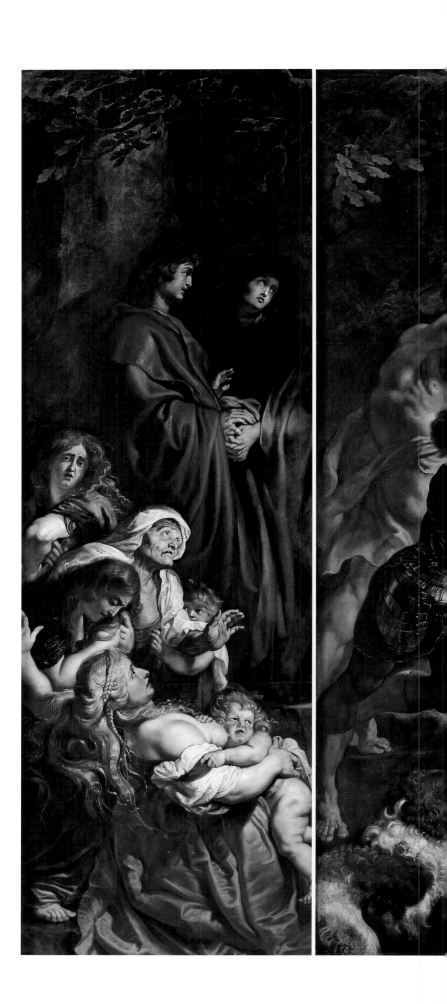

The Elevation of the Cross 1609–1610
Panel, 460 x 340 cm (central panel),
460 x 150 cm (side panels)
Altarpiece for the high altar in the church of
St Walburga in Antwerp

With this triptych Rubens convincingly
introduced the style of Baroque to those
living north of the Alps. The diagonal
composition is full of dynamism and a
lively play of colours. The artist had just
returned from Italy and cherished the
memory of Michelangelo, Caravaggio and
the Venetian masters. The vigorous move-
ments of the figures, the contrasts in the
way the light falls, the ruddiness of the
toiling bodies and the brilliance of the
harness and opulent robes enabled him to
demonstrate his budding talent. The
painting was seized by the French in 1794
and taken to Paris. It was returned to
Antwerp in 1815, after the period of French
rule had come to a close, and was allocated
to the Cathedral of Our Lady.

Outside of the side panels

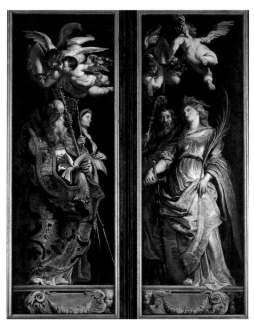

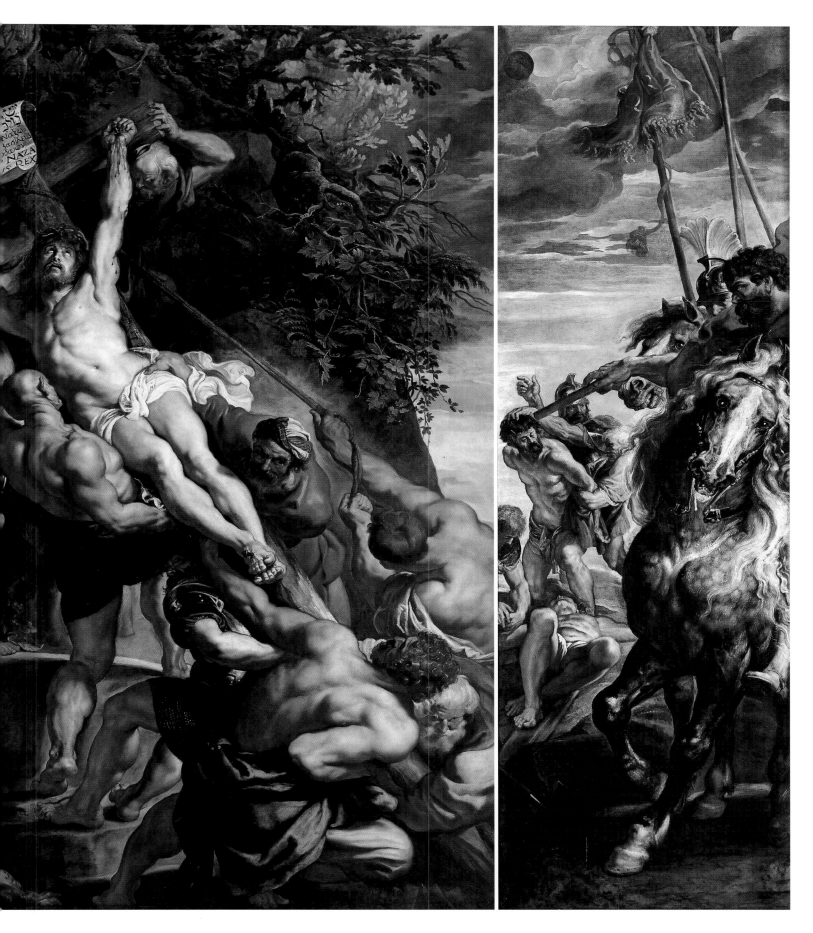

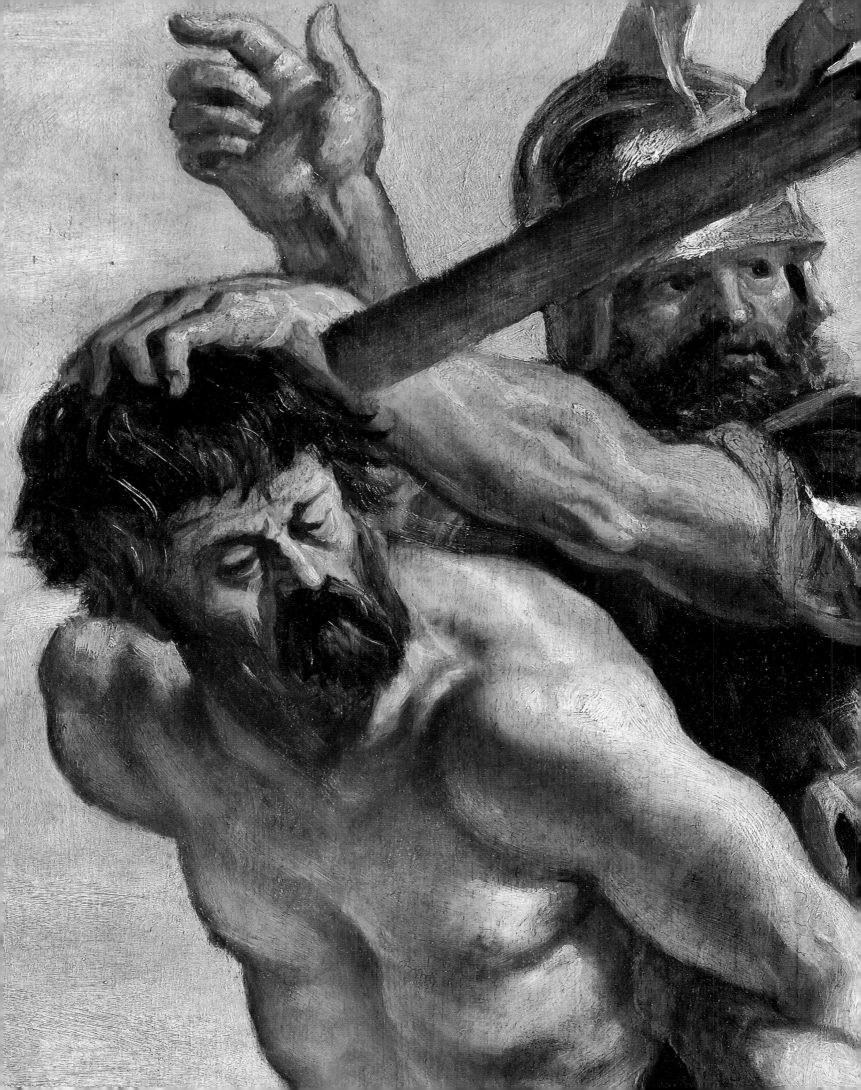

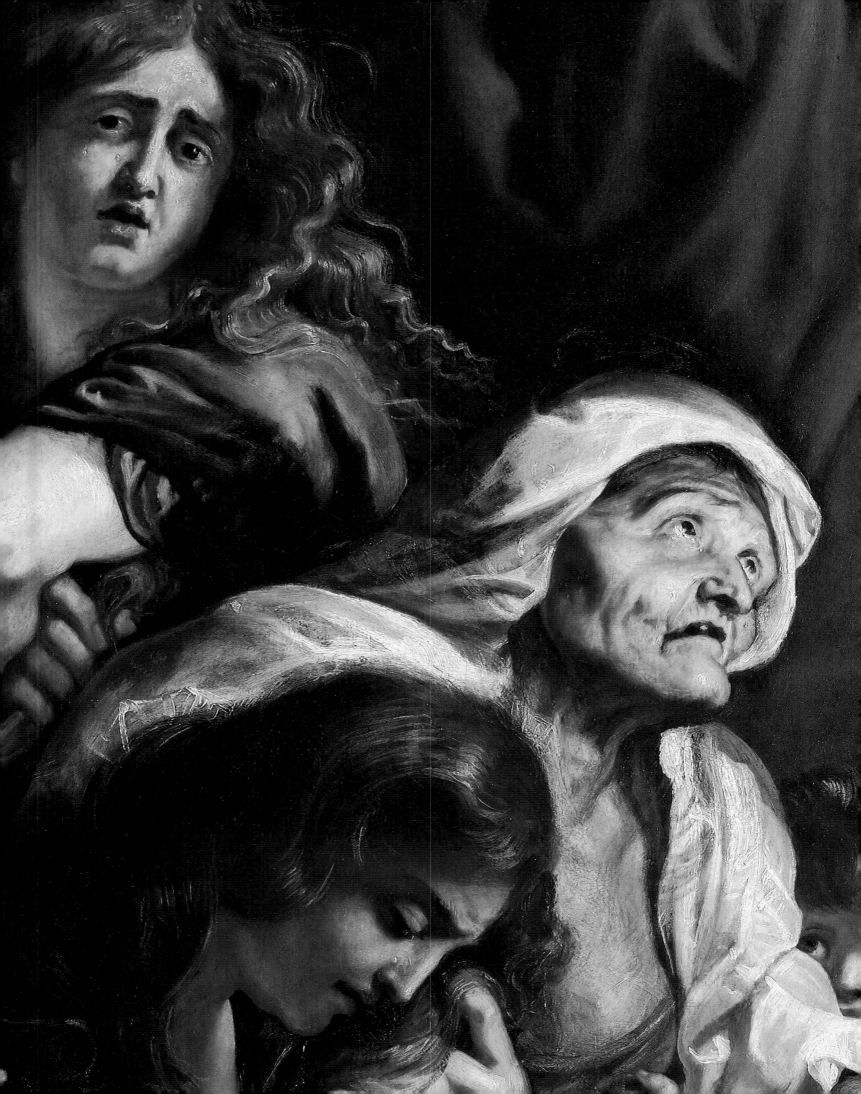

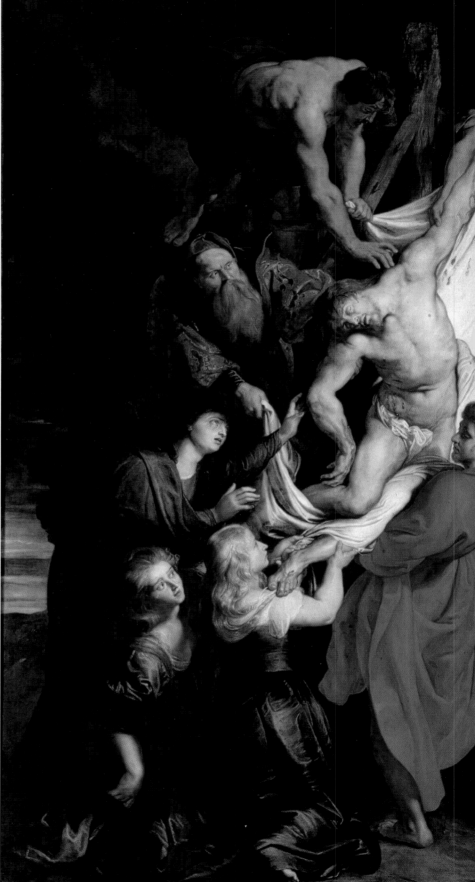

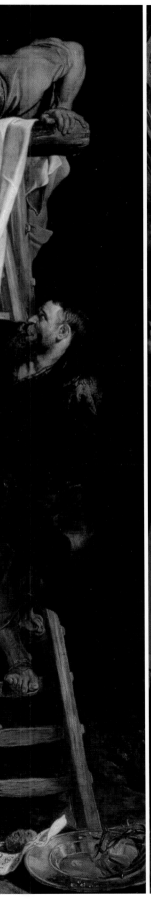
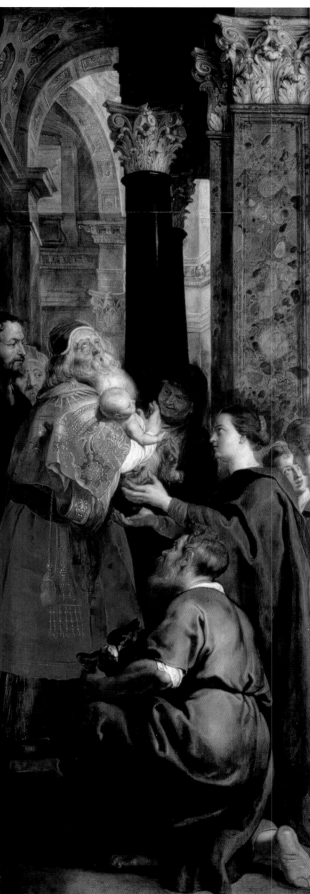

The Descent from the Cross 1611–1614
Panel, 421 x 311 cm (central panel),
421 x 153 cm (side panels)
Triptych from the altar of the Harquebusiers
in the Cathedral of Our Lady in Antwerp

The Antwerp Guild of Harquebusiers commissioned a *Descent from the Cross* from their famous fellow townsman Peter Paul Rubens in 1611. The captain of the guild at the time was the mayor, Nicolaas Rockox, who is shown in the painting (the man on the left in the right panel). At first sight the triptych contains highly divergent subjects, but in fact there is a connection between them. Rubens painted St Christopher, the patron saint of the Harquebusiers, on the rear of the left side panel. The Greek name of the saint, Christophoros, means 'bearer of Christ'. That contains the key to the entire composition: the friends and the holy women in the central panel and Mary and Simeon in the side panels are all 'bearers of Christ'.

Outside of the side panels

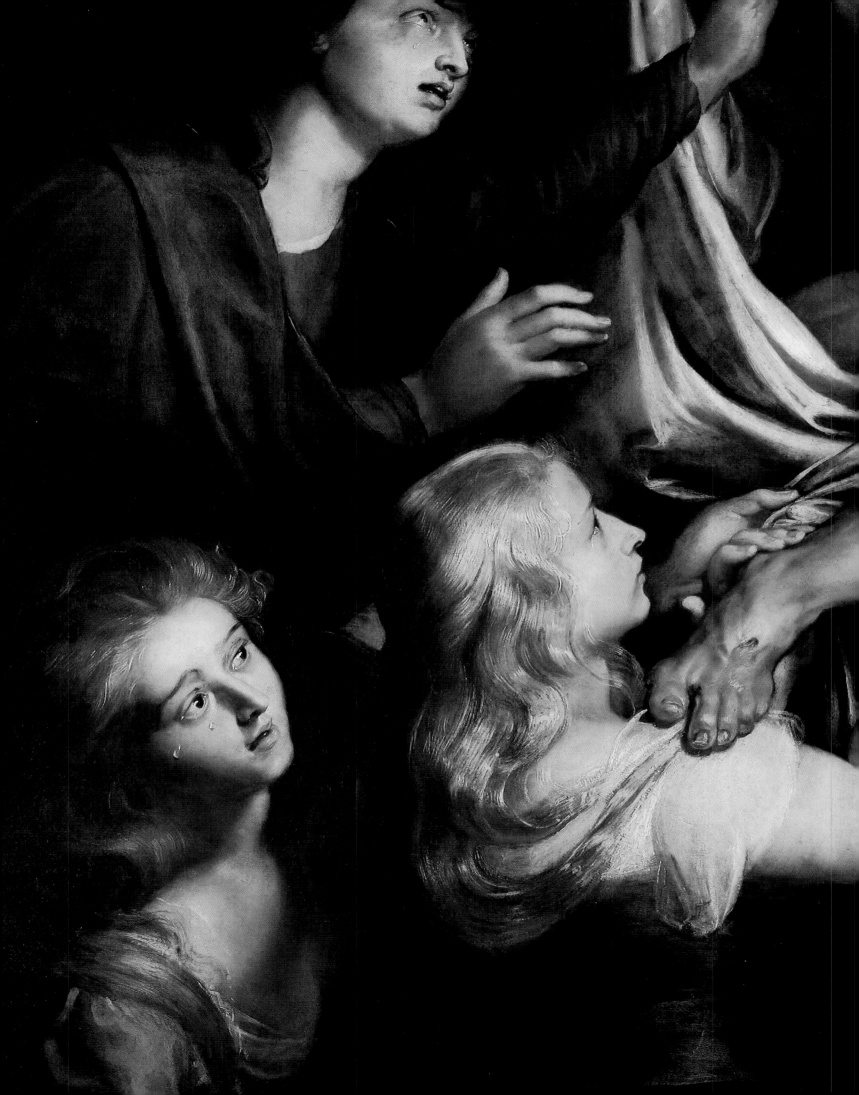

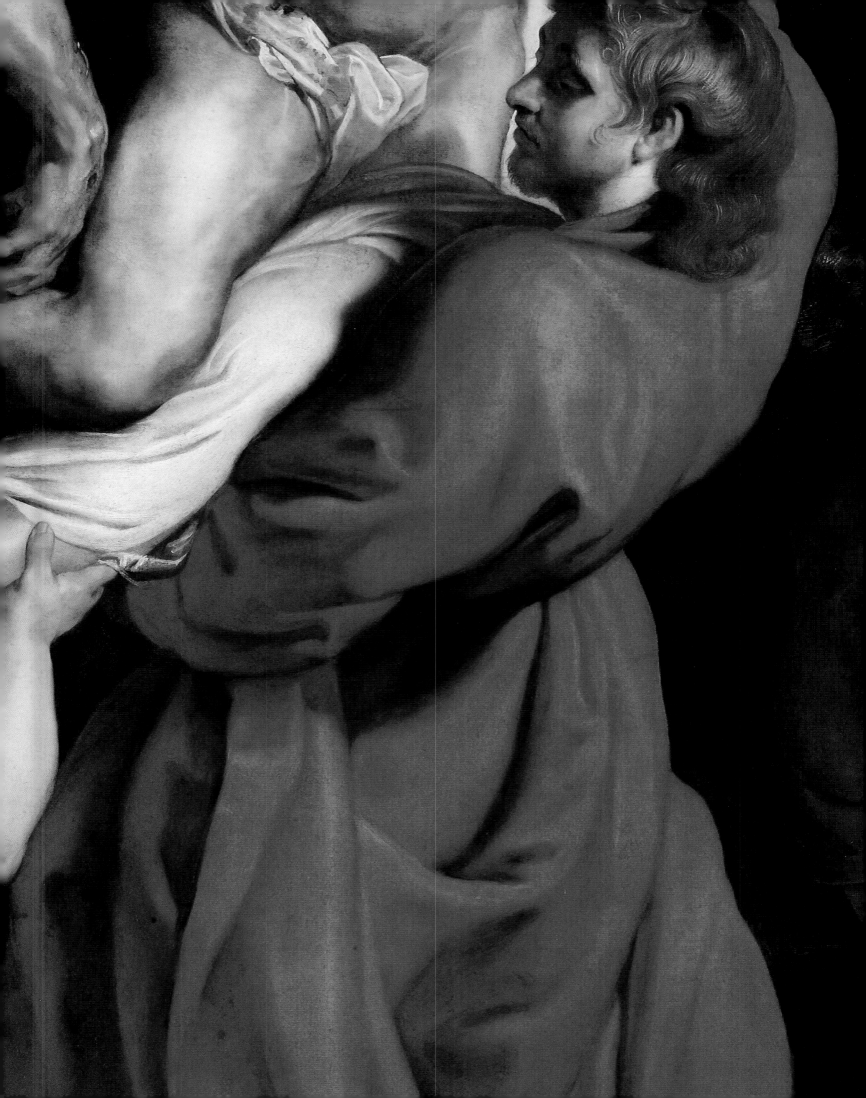

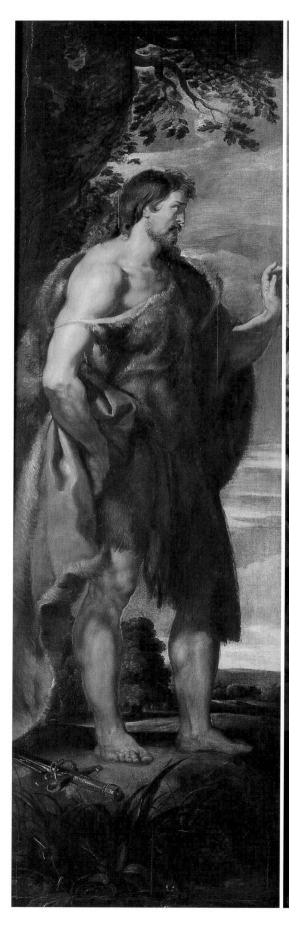
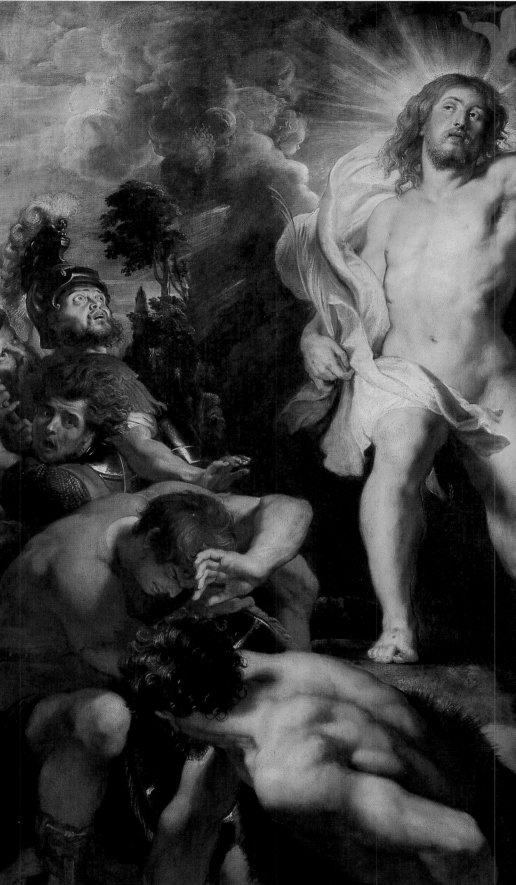

The Resurrection of Christ 1611–1612
Panel, 138 x 98 cm (central panel),
136 x 40 cm (side panels)
Epitaph triptych of Jan Moretus and Martina Plantin
in the Cathedral of Our Lady in Antwerp

Rubens painted the *Moretus Triptych* short-ly after completing *The Elevation of the Cross* and at roughly the same time as the cent-ral panel of *The Descent from the Cross*. The work was commissioned by Martina Plan-tin, the widow of the printer Jan Moretus. Christ steps vigorously from an open tomb in the rock, not from the sarcophagus that was customary in representations of this subject. The supernatural radiance of his body contrasts with the darkness in which the terrified soldiers move. The left-hand panel represents St John the Baptist, the patron saint of Jan Moretus, and the right-hand panel shows St Martina, the patron saint of Moretus's widow. The rear of the panels is splendid too. The two angels in light brown grisaille are strongly reminis-cent of classical statues. They resemble the angels that stood beside the tomb on the morning of the Resurrection.

Outside of the side panels

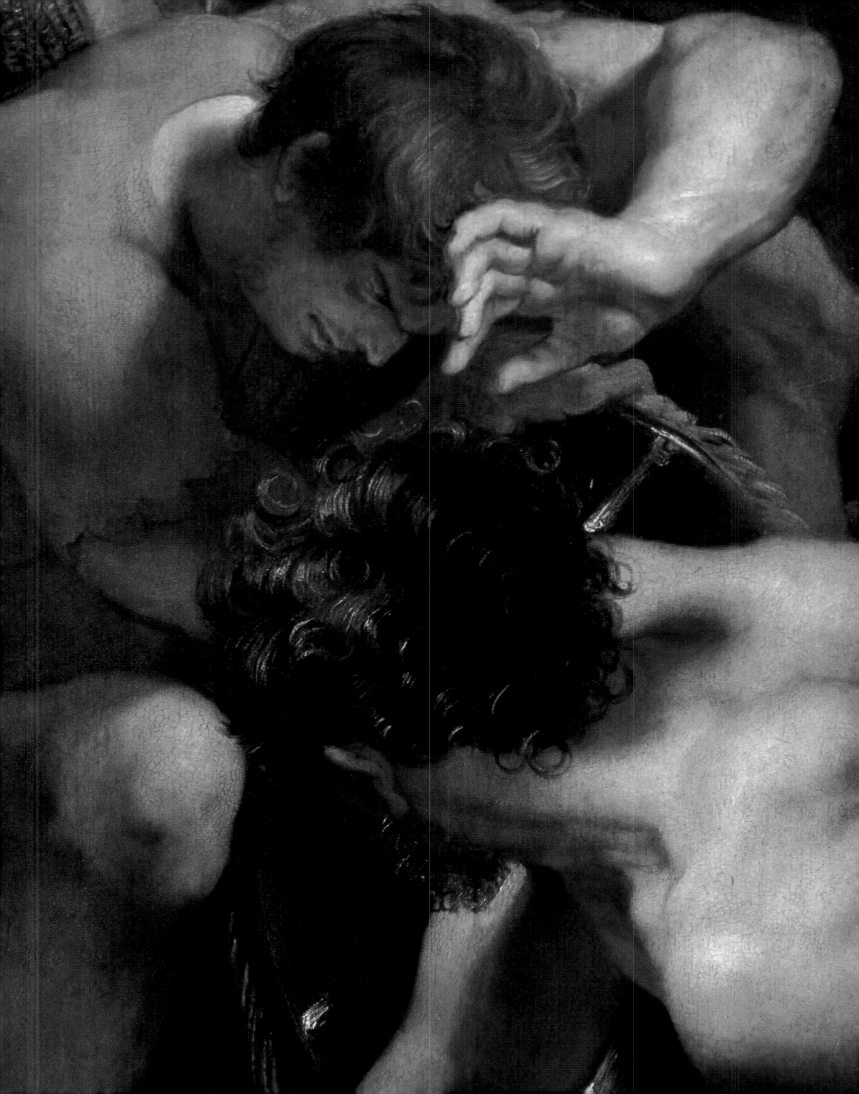

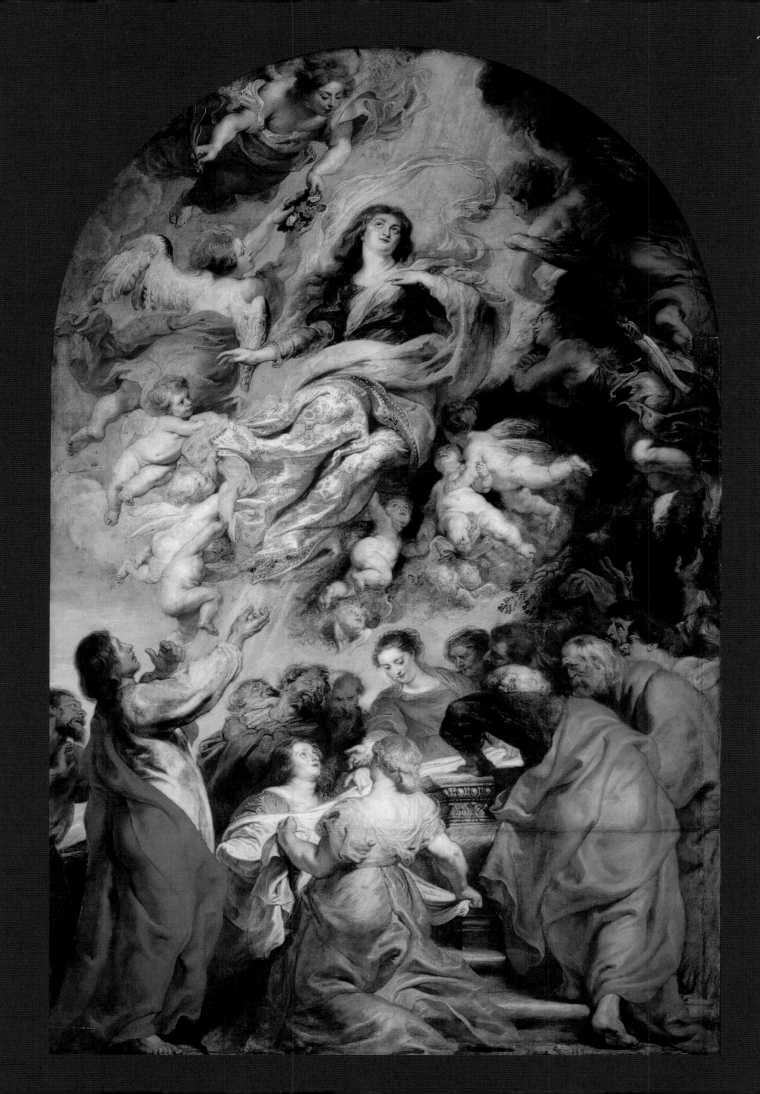

The Assumption of the Virgin 1625–1626
Panel, 490 × 325 cm
Altarpiece for the high altar of the
Cathedral of Our Lady in Antwerp

The 'Baroque' conversion of the cathedral
at the beginning of the seventeenth cen-
tury included a new marble high altar.
The altarpiece was commissioned from
Rubens, and was paid for by the deacon
Johannes del Rio. In return, the deacon
received permission from the chapter for
his future burial place to be situated at the
beginning of the northern choir aisle. The
Virgin is rendered graciously and in a live-
ly fashion, with her flapping robes and
delicate ribboning scarf. She is borne
upwards by sprightly *putti* in a cloud. In
the upper left two angels with a rosary are
preparing to crown her. At the bottom the
Twelve Apostles stand around her sarco-
phagus. The three women who, according
to the medieval legend, were present at the
death of Mary and buried her body are also
represented. The good-looking woman in
the centre, in a red dress, is more striking
than the other bystanders. She has the fea-
tures of Rubens's wife Isabella Brant, who
died in June 1626 while the artist was
working on this painting.

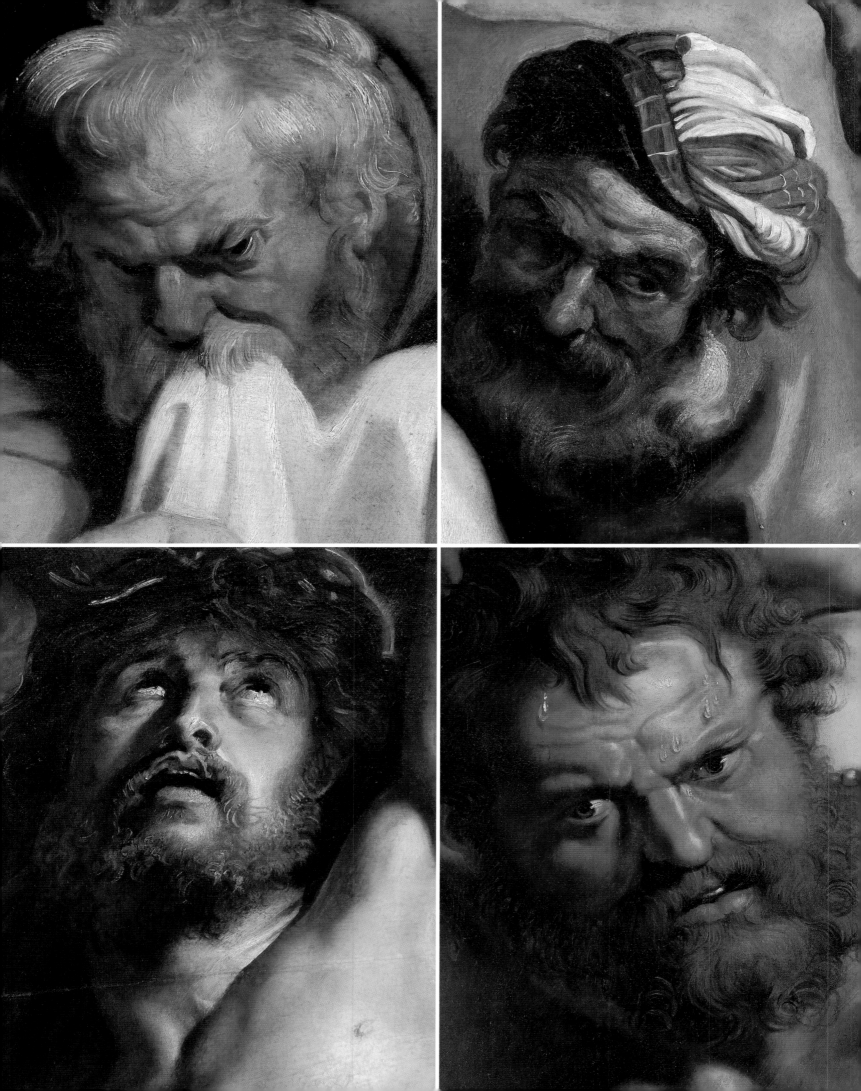

St Charles Borromeo's Church

Sculptural decoration of the west front of the Jesuit church in Antwerp (today St Charles Borromeo's church) c. 1620
Hans van Mildert 1585–1638
After designs by P.P. Rubens

St Charles Borromeo's church was built in 1615–1621. Rubens made designs for the west front and some of the interior features, such as the high altar and the ceiling of the Lady chapel. He probably also contributed to the design of the beautiful Baroque tower. The sculptural decoration of the high altar and the exterior was carried out by Hans van Mildert. Rubens also produced three paintings for this church (now in Vienna, Kunsthistorisches Museum) and, with the assistance of the studio, a series of paintings for the ceiling, which were destroyed by the fire of 1718.

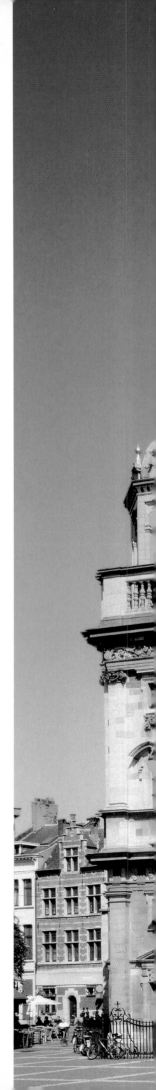

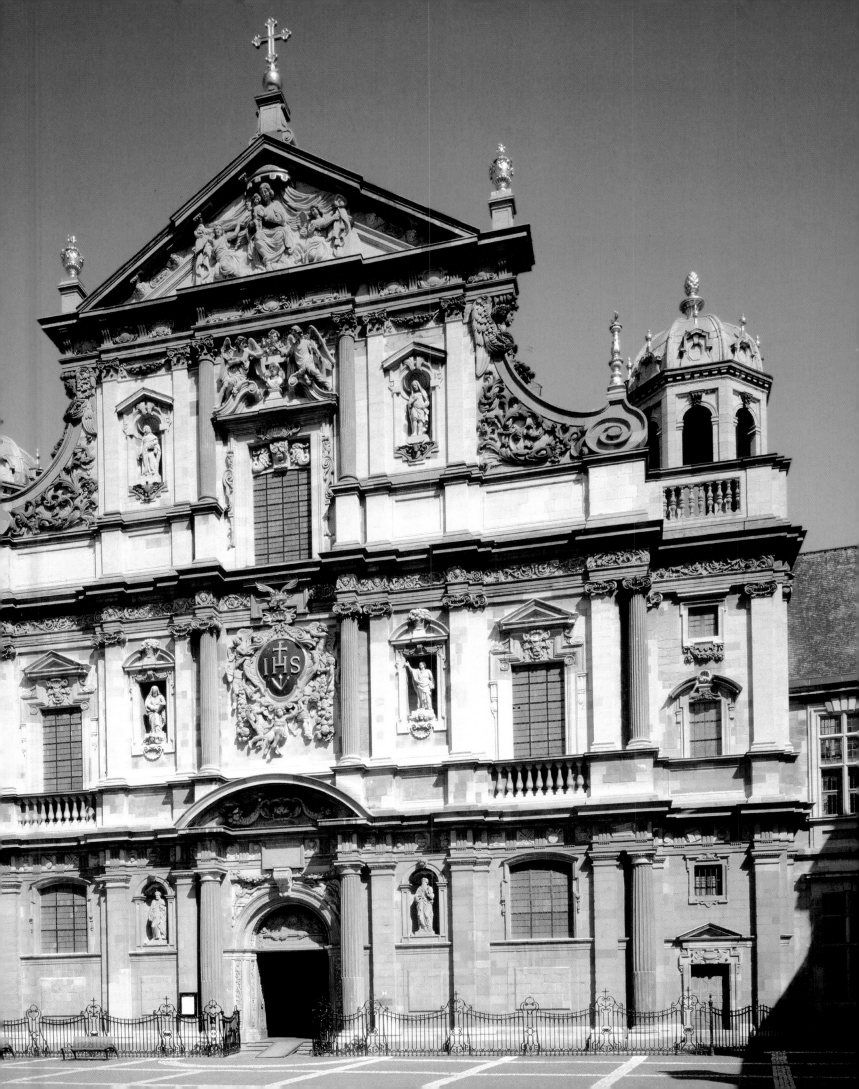

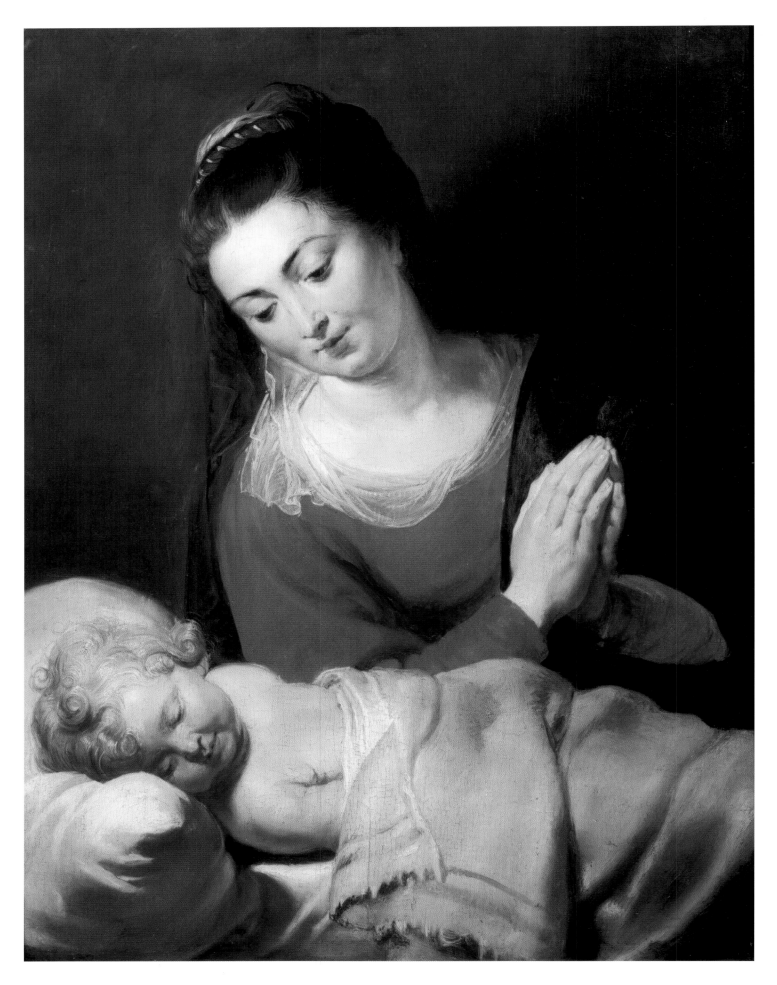

Rockox House

< Mary in Adoration before the Sleeping Infant
c. 1615
Panel, 65 x 50 cm

The small format and the intimate subject indicate that this painting was intended for a small room. It probably hung as a devotional object in a quiet corner of a home, in a bedroom, or above a domestic altar where it invited prayer and contemplation. The work is a good example of the 'classical' period (1612–1615): a peaceful composition with 'sculpturally' painted figures in a somewhat cold palette, all endowed with a silvery sheen.

Christ on the Cross c. 1627
Panel, 51 x 38 cm
Oil sketch

Rubens made this oil sketch as a preliminary work for an altarpiece for the church of St Michael in Ghent, but the painting was never executed – the commission was given to Antoon van Dyck.

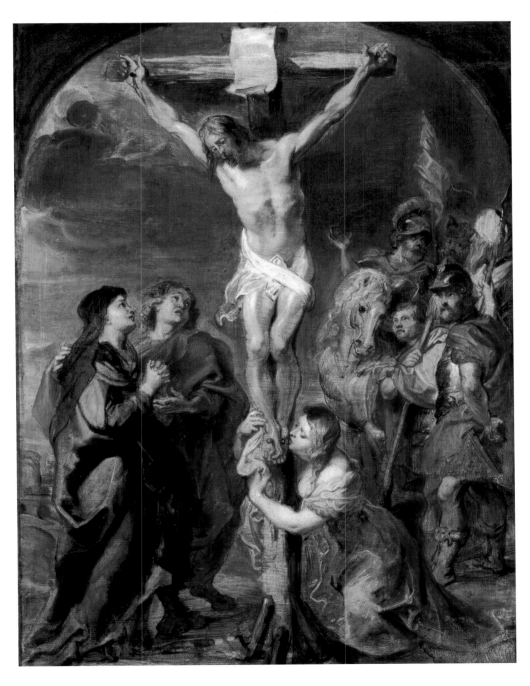

St Paul's Church

The Disputation on the Nature of the Holy Sacrament
c. 1609
Panel, 377 x 248 cm
Altarpiece for the chapel of the Holy Sacrament in the Dominican church in Antwerp (the present St Paul's church)

This painting was one of the first commissions that Rubens received after his return to Antwerp in 1608. It was commissioned by the fraternity of the Holy Sacrament for the altar of their chapel in the Dominican church. The theme is connected with that commission. An altar with a Holy Sacrament in a monstrance is surrounded by a company of bishops, monks, church fathers and other learned saints. Above them in the sky hover God the Father, the Holy Spirit (in the form of a dove) and angels with sacred texts. All of the elements in the composition are intended to drive home forcefully the message that during the celebration of the Eucharist the bread and the wine really are converted into the body and blood of Christ. This mystery of the transubstantiation was a tenet of Roman Catholic doctrine that was contested by the Protestants, and which was therefore vigorously defended during the Counter-Reformation.

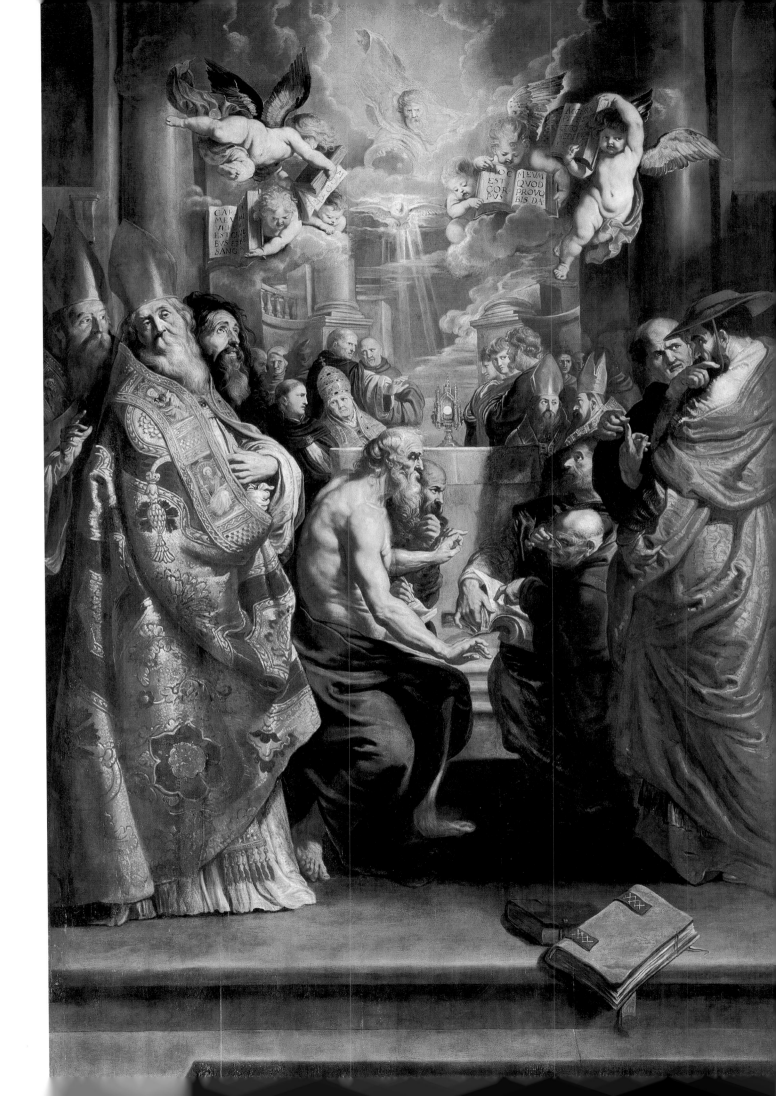

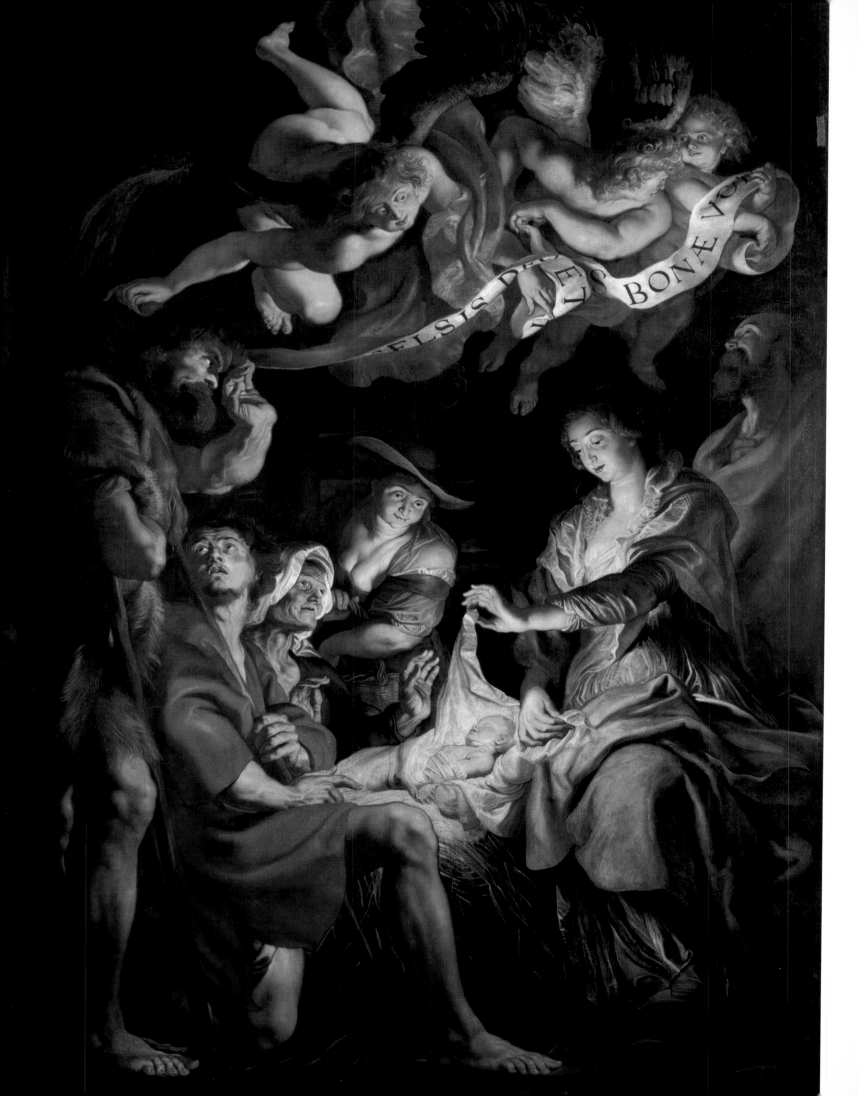

The Adoration of the Shepherds c. 1610
Canvas, 400 x 294 cm

It is not known who commissioned this painting, nor when it was placed in the church, but it may be assumed that it belonged here from the start. It is one of Rubens's early works, painted after his return to Antwerp. The composition reveals a close affinity with an *Adoration of the Shepherds* that he painted in Italy in 1608 for the church of the Oratorians in Fermo. The representation of Christmas night with the divine Child as the source of light probably betrays the influence of Correggio's famous painting *Notte*, which Rubens may have seen in Italy. The light is reflected on the bystanders and on the angels above, and creates strong contrasts between light and dark. Caravaggio may have been a source of inspiration for this effect, as well as for the depiction of several peasant types. Rubens had also picked up the rich 'Venetian' palette in Italy, as other works from this first period show. In later years the artist returned to this type of Christmas night on several occasions, for example for a design for a book illustration, a *modello* for a ceiling painting, a few paintings, drawings and an oil sketch (Antwerp, Rubens House). They all have a certain affinity with the version from Fermo and with the more lively and monumental version from the Dominican church in Antwerp.

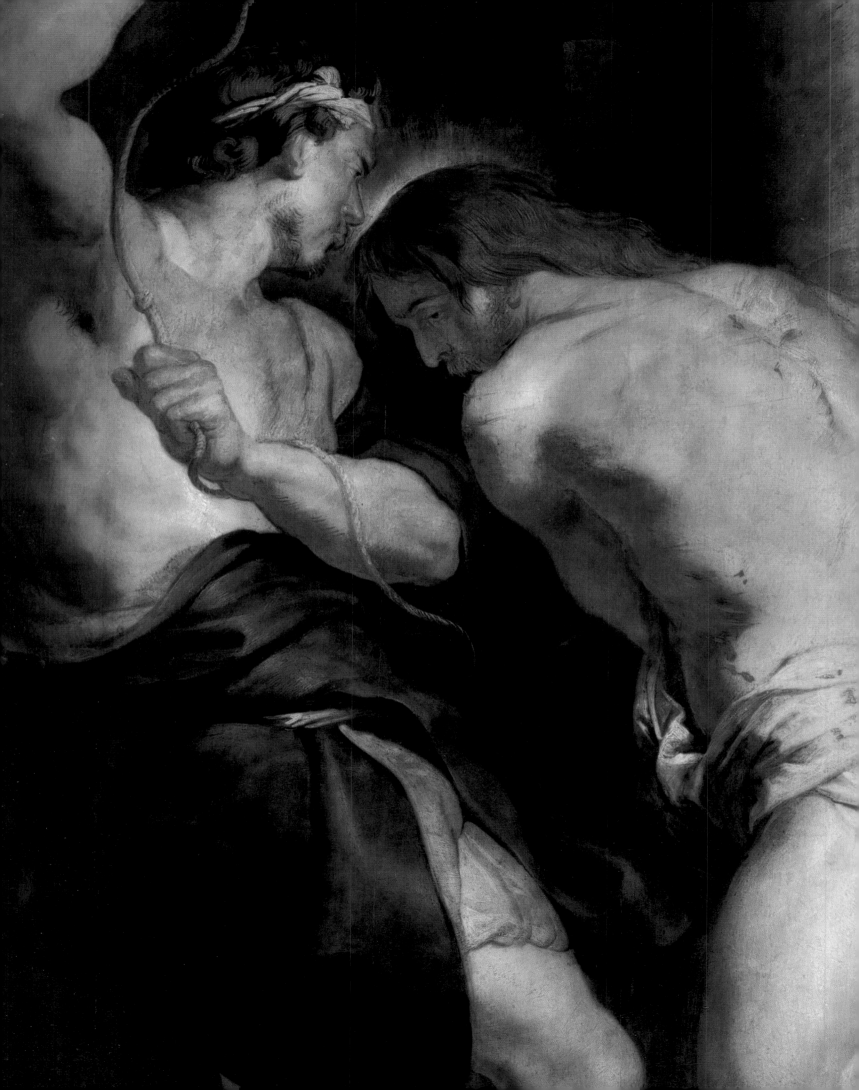

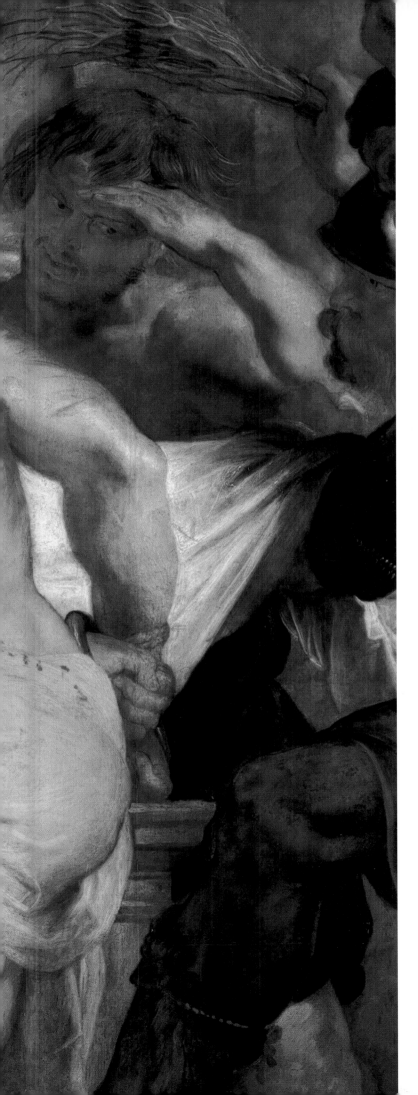

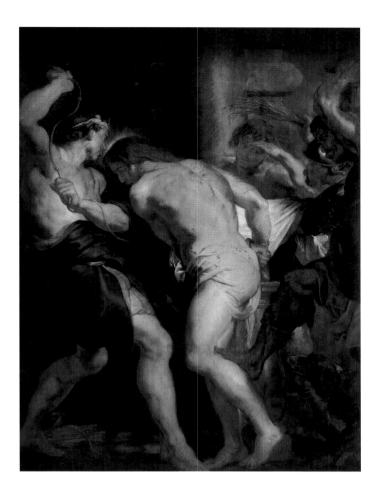

The Scourging at the Pillar c. 1617
Panel, 219 x 161 cm
Panel from the series *The Mysteries of the Rosary*
in the Dominican church (now St Paul's church) in
Antwerp

Thanks to the generosity of well-to-do citizens of Antwerp, the Dominicans were able to decorate their church with a series of 15 panels on the theme of *The Mysteries of the Rosary*. These mysteries form a part of Roman Catholic devotion. Rubens's composition undoubtedly took into account the place that the painting would be given, fairly high on a side wall: the figures are clearly delineated in the foreground like a group of sculptures against a neutral architectural background. Christ seems to want to turn to the praying faithful, but is prevented from doing so by his chains and by the foot of the black torturer who stops him from turning towards us.

St Anthony's Church

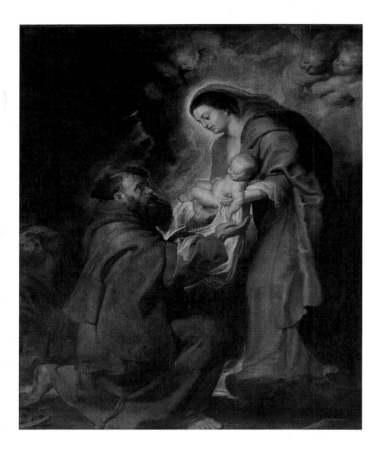

St Francis of Assisi Receives the Infant Jesus
from Mary no date
Canvas, 230 x 173 cm
Altarpiece for the Capuchin church in Antwerp

This canvas was painted for the church of the Capuchins,
a branch of the Franciscan order, in the Paardenmarkt in
Antwerp. St Anthony's church, where the painting hangs
today, was built on the site of the former monastery in the
nineteenth century.

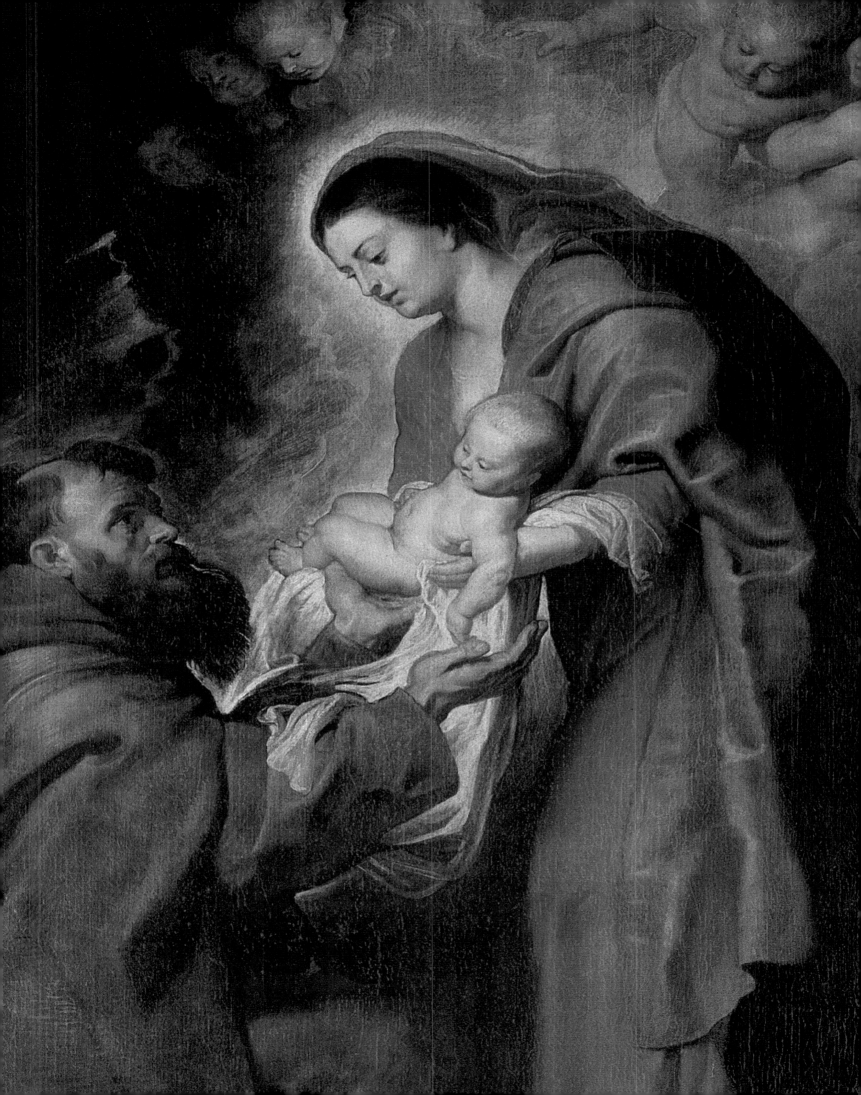

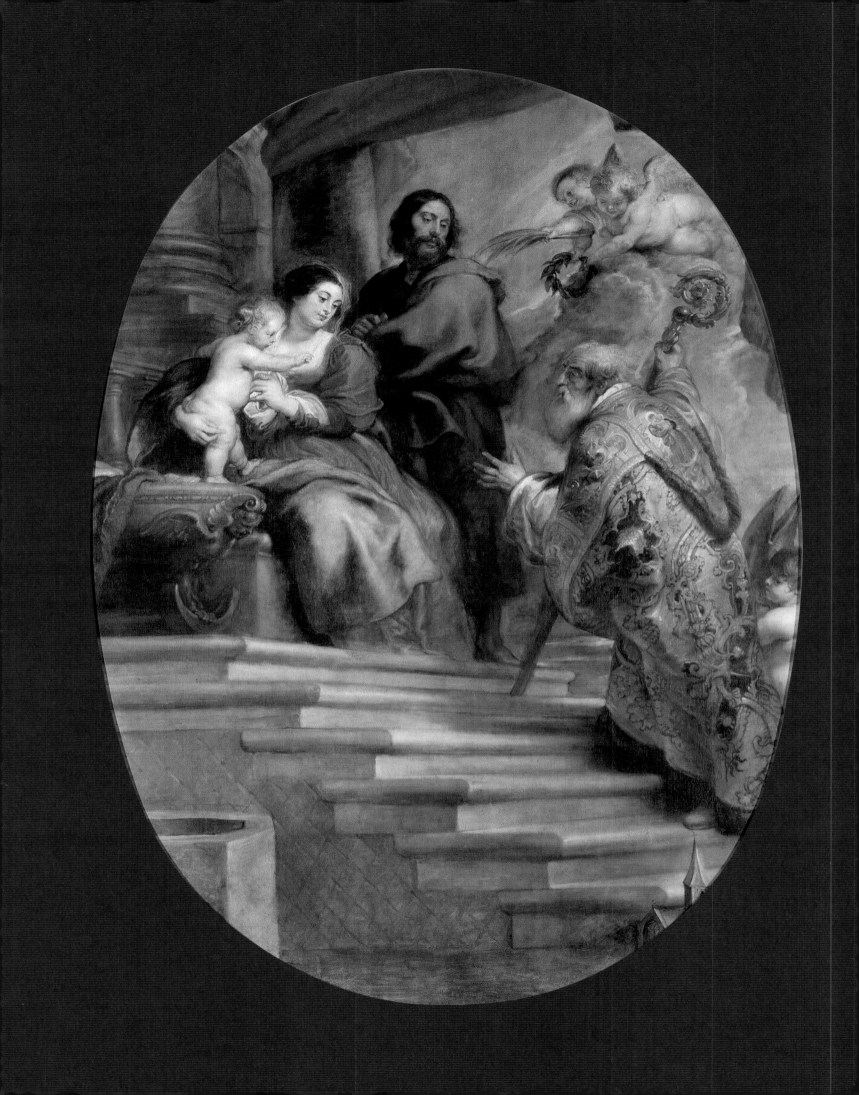

St Willibrod's Church

Saint Willibrod in Adoration before Mary Mother of God c. 1630–1631
Canvas, 395 x 315 cm
Altarpiece for the chapel of Our Lady in the Droogscheerderskapel of Antwerp. With assistance from the studio

St Willibrod's church in Berchem now lies inside the Antwerp ring road, but in the seventeenth century it was a parish outside the city. After the end of the Twelve Years Truce hostilities were resumed in the Netherlands and the outskirts of the city were no longer safe, so the parish of St Willibrod moved to a location inside the city walls, namely the Droogscheerderskapel in the Keizerstraat. The brotherhood of Our Lady that was established in this chapel was given an altarpiece that had been commissioned from Rubens by a benefactor. Later, after the end of the war in 1648, the whole contents of the chapel went back to Berchem, and since then the painting has hung in St Willibrod's church. The work, in which the studio certainly played a part, was initially rectangular. The format was changed in the first quarter of the eighteenth century when oval altarpieces came into fashion.

St James' Church

Our Lady, the Christ Child and Saints 1638–1639
Panel, 211 x 195 cm

A few days before his death, Rubens said that he would like to dedicate this painting to the funerary chapel that the Fourment family was later to establish for him in St James' church. That is what happened: the chapel was completed a few years later and the painting was given a place there. Since the work was not painted as a funerary decoration, it does not contain a theme referring to death, resurrection or the afterlife. The significance of the saints surrounding Mary and the Christ Child is unclear. The one in armour is St George, the woman in the front is Mary Magdalene, and the half-naked old man to the lower right is the learned Church father, hermit and penitent Hieronymus, a figure who often appears in Rubens's oeuvre. Jesus has the features of Frans Rubens, the first child of Rubens and Helena Fourment. This panel, one of the last works to be painted by Rubens, is an example of the virtuoso brushwork and warm tonalities that characterise his work of the 1630s, the 'lyrical' period.

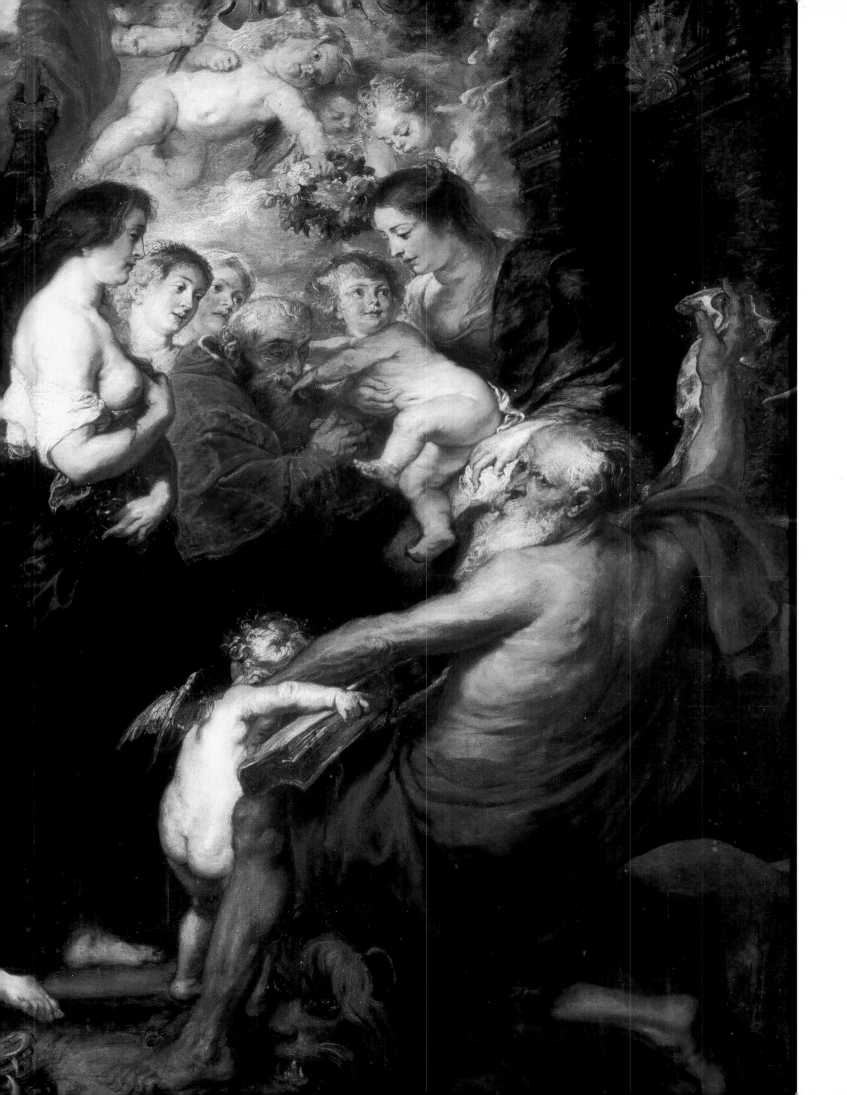

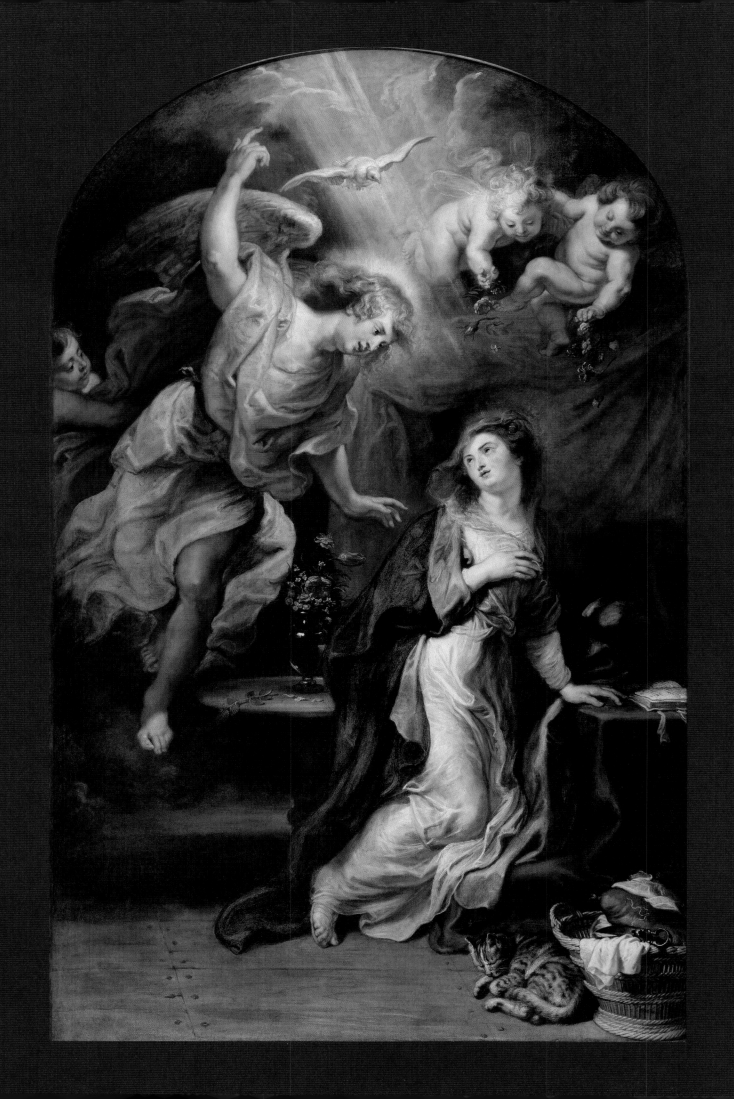

The Rubens House

The Leganés Annunciation before 1628
Canvas, 310 x 178.6 cm

In terms of content, this dynamic, thoroughly Baroque Annunciation is a fairly traditional rendering of the theme with several of the customary requisites such as a sewing basket, a sleeping cat, a vase of flowers and a prayer book. When Rubens was dispatched on a diplomatic mission to the Spanish court in 1628, he took this canvas with him – or rather, had it sent on – and sold it in Madrid to Don Diego Mexia Filipe de Guzman, first marquis of Leganés. This military officer and diplomat in the service of the Spanish king owned an impressive art collection. He had Rubens's painting hung in his private chapel.

Henry IV in the Battle of Paris c. 1628–1630
Canvas, 174 x 260 cm
Unfinished painting
Landscape with battle is by a different artist (possibly
Peeter Snayers)

This work is listed in the inventory compiled after Rubens's death as 'one of the six large and unfinished pieces, comprising sieges of towns, battles and victories of Henry IV, king of France, which was begun a few years ago for the gallery of the Hôtel de Luxembourg, for the dowager queen of France'. The artist was commissioned to start work on the series concerning the life of King Henry IV by Marie de' Medici, but as a result of political developments – she had to flee from her own son Louis XIII – the paintings remained unfinished. This canvas evokes a battle near Paris on 12 March 1590, where Henry IV defeated his political opponents in one hour. The monumental painting was done in collaboration with a specialist in the genre of battle scenes. The background with the battlefield was probably executed by the Brussels landscape painter Peeter Snayers (1592–after 1666). Unfortunately, the previous owner had the painting considerably reduced in size, with the result that most of the landscape by Snayers has disappeared.

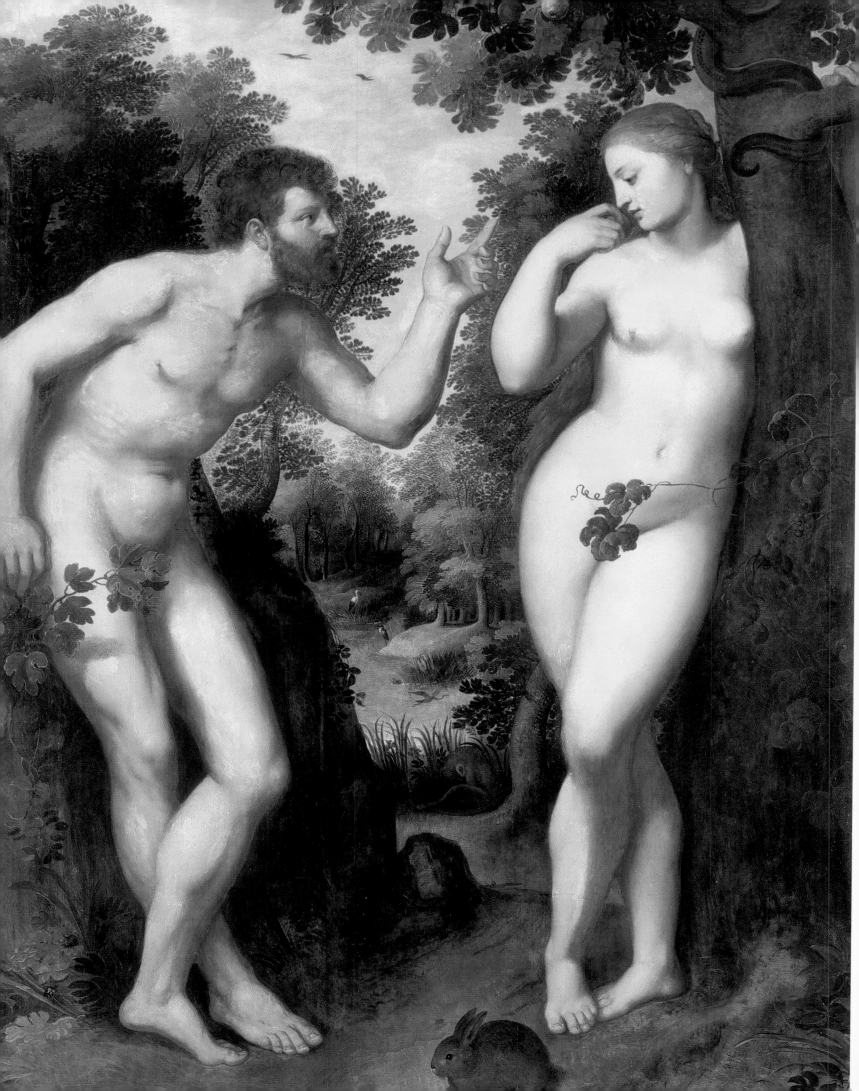

Adam and Eve before 1600
Panel, 182.5 x 140.7 cm

This panel with Adam and Eve in Paradise (some scholars regard this as Rubens's most important work before his departure for Italy, others question whether it should be attributed to Rubens at all) is clearly inspired by a print by Marcantonio Raimondi after Raphael. The late Mannerist and Classicising style, the cool palette, and the firmly delineated contours betray the influence of Rubens's mentor, Otto van Veen, but Rubens's later Baroque style can already be detected in the move toward a more plastic rendering of the bodies and above all in his personal interpretation of the print. That is expressed particularly in the dramatic gesture of Adam's left hand: he is not offering Eve the apple, as in the print, but with his index finger he appears to be warning her and at the same time pointing to the serpent that has coiled itself around the tree above Eve's head.

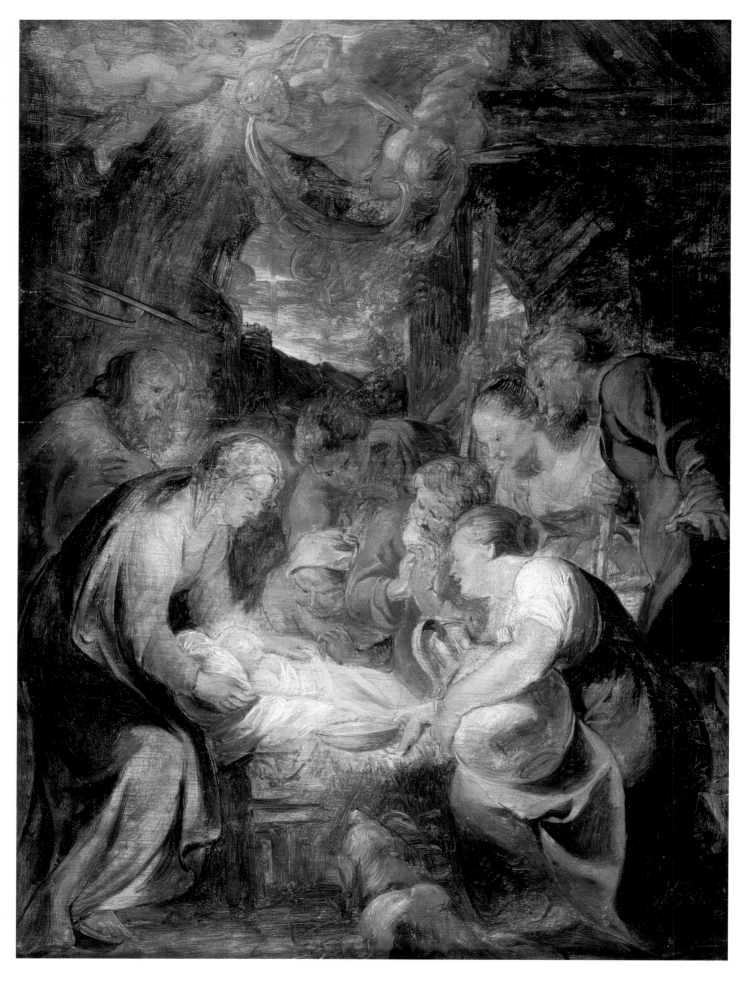

< The Adoration of the Shepherds
(Sketch for a Christmas Night) c. 1615–1616
Panel, 46 x 34 cm
Oil sketch

Rubens here combines a carefully balanced composition and the use of colour to achieve harmony and coherence. The contrast between light and dark is not intensified à la Caravaggio, but is toned down and is rich in nuances. Rubens painted several versions of *The Adoration of the Shepherds*, with variations but also with recognisable features that recur in several versions. No finished painting based on this oil sketch is known.

> Portrait of Michael Ophovius 1617
Canvas, 114.5 x 85 cm

Michael Ophovius was prior of the Antwerp Dominicans. In 1626 he was appointed bishop of 's-Hertogenbosch by the Infanta Isabella. After the capitulation of the city to the United Provinces, he fled to the Southern Netherlands and settled in the Dominican vicariate that he had set up in Lier. According to a later source, Ophovius was Rubens's confessor. It is not unlikely that Rubens designed the elaborate tomb for Ophovius in the Church of St Paul in Antwerp. This captivating portrait is a copy that was made by Rubens's studio under the master's supervision. The original version hangs in the Mauritshuis in The Hague. It was common practice at the time to make copies of paintings of prominent figures for several buyers.

>> Self-Portrait c. 1630
Panel, 61.6 x 45.1 cm

Besides the works in which Rubens portrayed himself with his family or friends, there are only four self-portraits known. The Rubens House owns one of them. The artist, about fifty years old at the time, presents the viewer with a friendly and interested gaze. His amiable appearance corresponds entirely to the description that contemporaries gave of his character and appearance. He appears here as 'the lovable Mr Rubens' who was 'so gentle in his manner' that everyone loved him and admired him for 'the great mildness of his conversation'. This portrait also expresses his mood of Stoic equanimity and refined humanist erudition.

The Triumph of Saint Clare 1620
Panel, 28 x 36.5 cm
Oil sketch, *modello* for one of the ceiling paintings in the Jesuit church in Antwerp

Rubens painted this *modello* in 1620 for one of the 39 ceiling paintings in the Jesuit church in Antwerp. A *modello* is a more elaborated oil sketch on the basis of a preliminary rough grisaille sketch. The contract stipulated that Rubens was to do the *modelli* himself; he could execute the ceiling paintings with his best pupils, including Antoon van Dyck. According to legend, the advancing Islamic army took to flight upon seeing the monstrance that St Clare pointed at them from a hill.

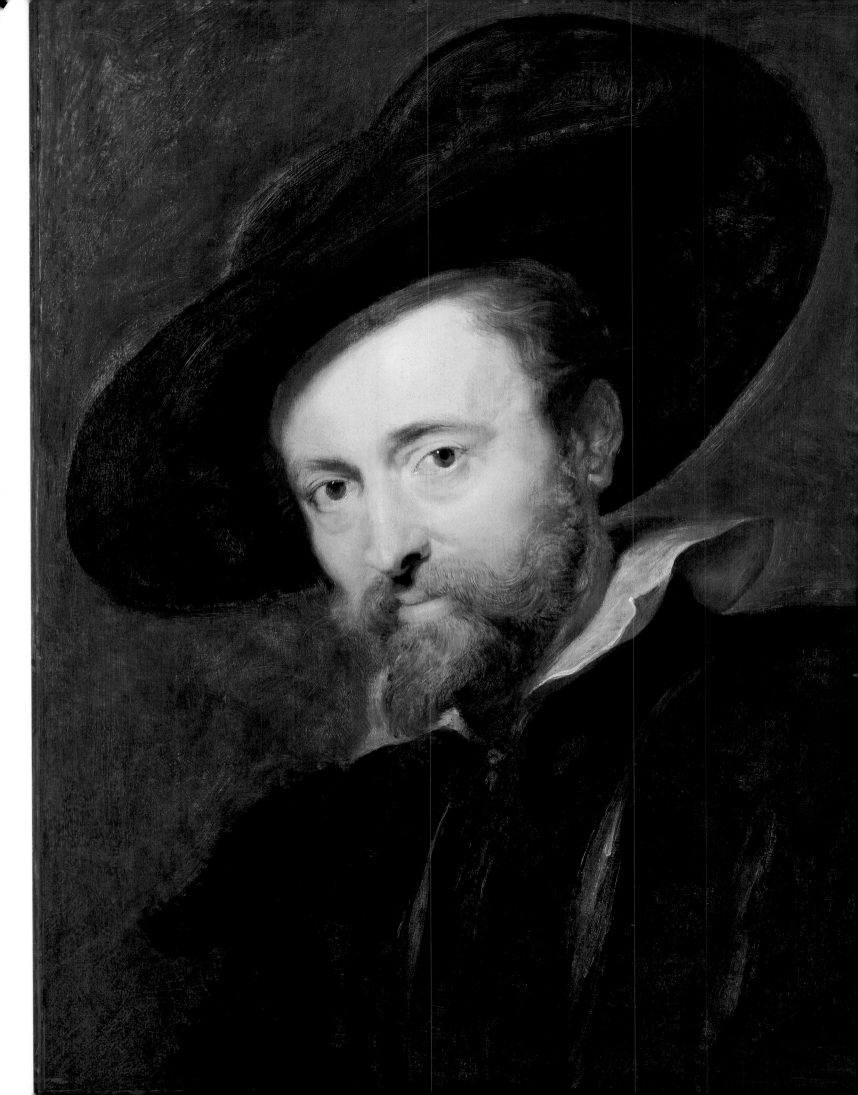

Bibliography

Frans Baudouin, *P.P. Rubens*, Mercatorfonds, Antwerp 1977.

P.P. Rubens – Schilderijen, schetsen, tekeningen, exhibition catalogue, Koninklijk Museum voor Schone Kunsten, Antwerp 1977.

Herman Liebaers, Valentin Vermeersch, Leon Voet, Frans Baudouin, Robert Hoozee et al., *Flemish Art from the Beginning till Now*, Alpine Fine Arts Collection (UK) Ltd, London 1985.

Karel Van Isacker and Raymond Van Uytven, *Antwerpen – Twaalf eeuwen geschiedenis en cultuur*, Mercatorfonds, Antwerp 1986.

Catalogus Schilderkunst Oude Meesters, Ministerie van de Vlaamse Gemeenschap, Koninklijk Museum voor Schone Kunsten, Antwerp 1988.

Francine De Nave and Leon Voet, *Plantin-Moretus Museum Antwerp*, in the series Musea Nostra, Gemeentekrediet, Ludion, Brussels 1989.

Paul Huvenne and Hans Nieuwdorp, *Rubens House Antwerp*, in the series Musea Nostra, Gemeentekrediet, Ludion, Brussels 1990.

Els Maréchal and Leen de Jong, *The Royal Museum of Fine Arts Antwerp*, in the series Musea Nostra, Gemeentekrediet, Ludion, Brussels 1990.

Arthur K. Wheelock Jr, Susan J. Barnes, Julius S. Held et al., *Van Dyck – Paintings*, National Gallery of Art, Washington / Mercatorfonds, Antwerp 1991.

Peter C. Sutton et al., *The Age of Rubens*, Mercatorfonds, Antwerp 1993.

Van Bruegel tot Rubens. De Antwerpse schilderschool 1550–1650, exhibition catalogue, Antwerp 1993.

R.-A. d'Hulst et al., *Jacob Jordaens*, 2 vols, exhibition catalogue, Antwerpen 93, Gemeentekrediet, Brussels 1993.

Susan Koslow, *Frans Snyders stilleven- en dierenschilder*, Mercatorfonds, Antwerp 1995.

Hans Devisscher and Paul Huvenne, *Rubens & Antwerpen*, CD-ROM, Stad Antwerpen, Photogravure De Schutter, Tijdsbeeld, Antwerp 1998.

Irene Smets, *The Royal Museum of Fine Arts Antwerp: One Hundred Masterpieces from the Collection*, Ludion, Ghent 1999.

Irene Smets, *The Cathedral of Our Lady in Antwerp*, Ludion, Ghent 1999.